Juls & Jess

May your memories
of NYC always
bring you JOY!

With love,
Mom & Dad
2022

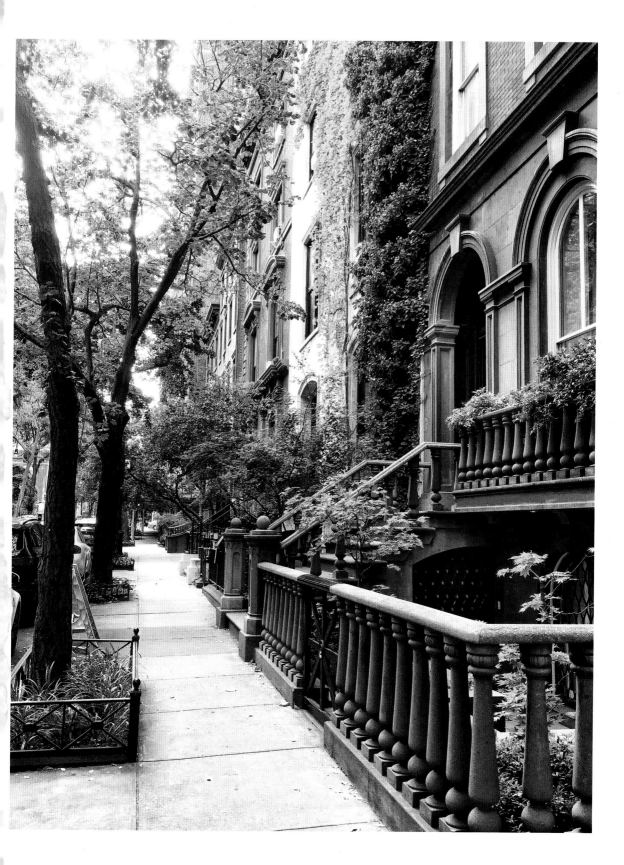

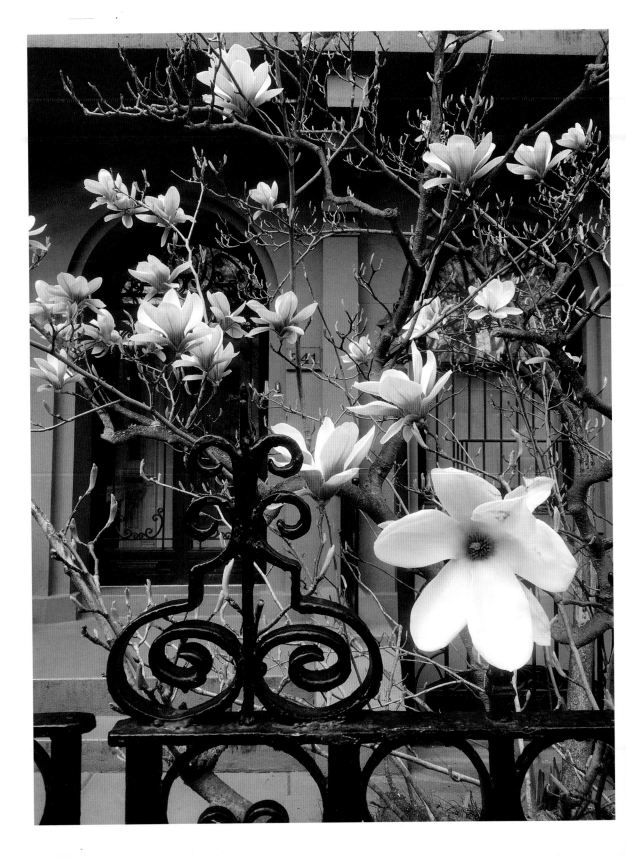

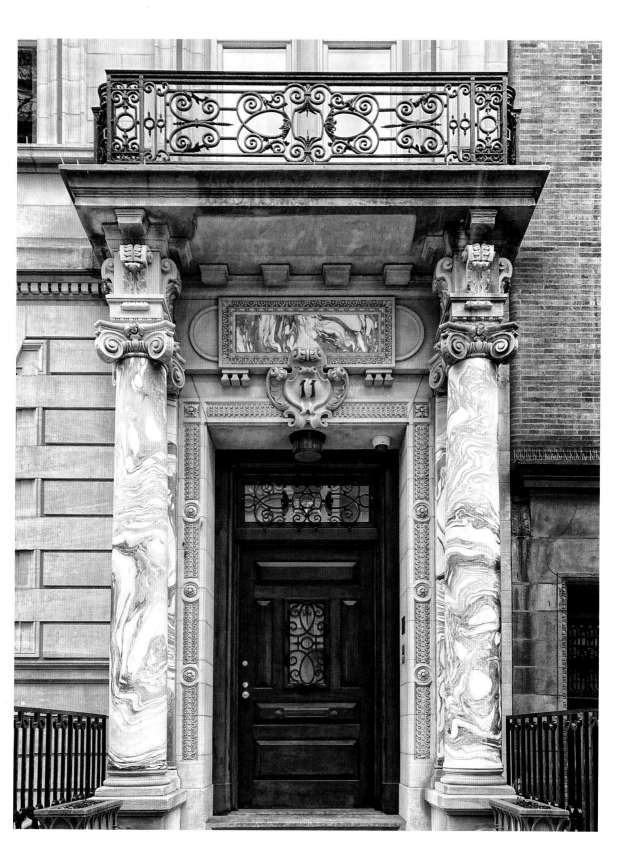

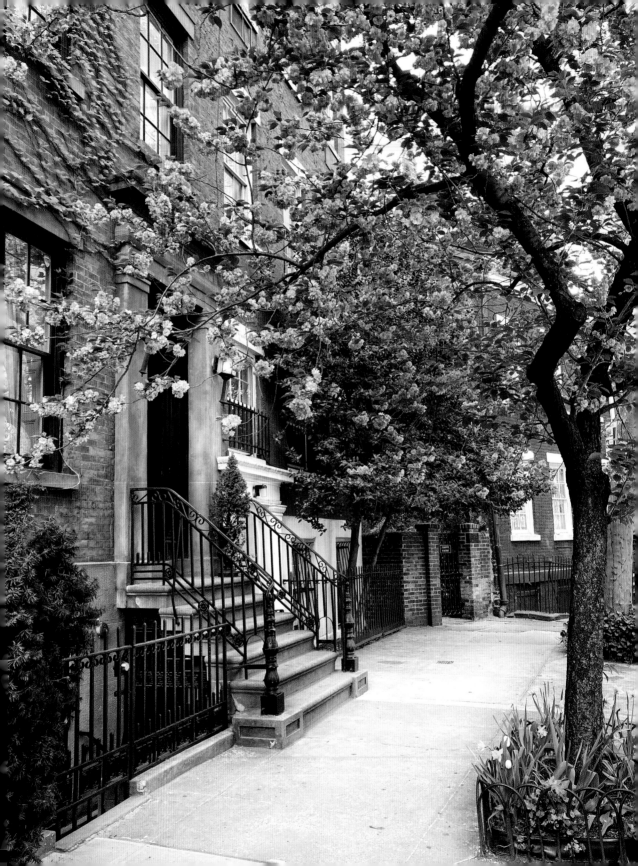

Walk With Me

NEW YORK

THE BEAUTY OF NEW YORK THROUGH THE LENS OF

SUSAN KAUFMAN

ABRAMS IMAGE, NEW YORK

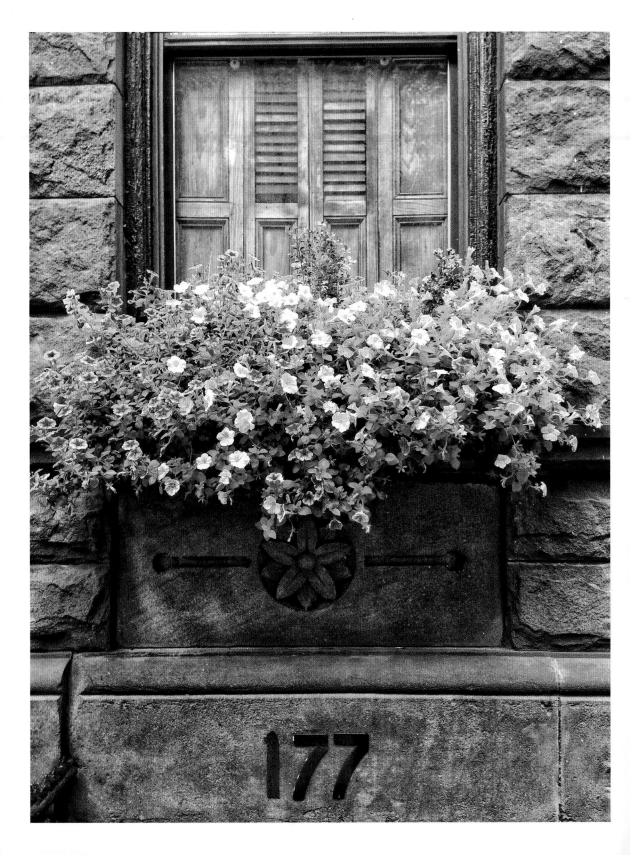

Contents

Introduction 9

**NEIGHBORHOODS AND MAPS
OF MY FAVORITE STREETS**

Greenwich Village 13

West Village 31

East Village 51

NoHo & Nolita 65

SoHo 81

Gramercy Park 99

Murray Hill 113

Upper East Side 127

Carnegie Hill 143

Brooklyn Heights 157

Acknowledgments 175

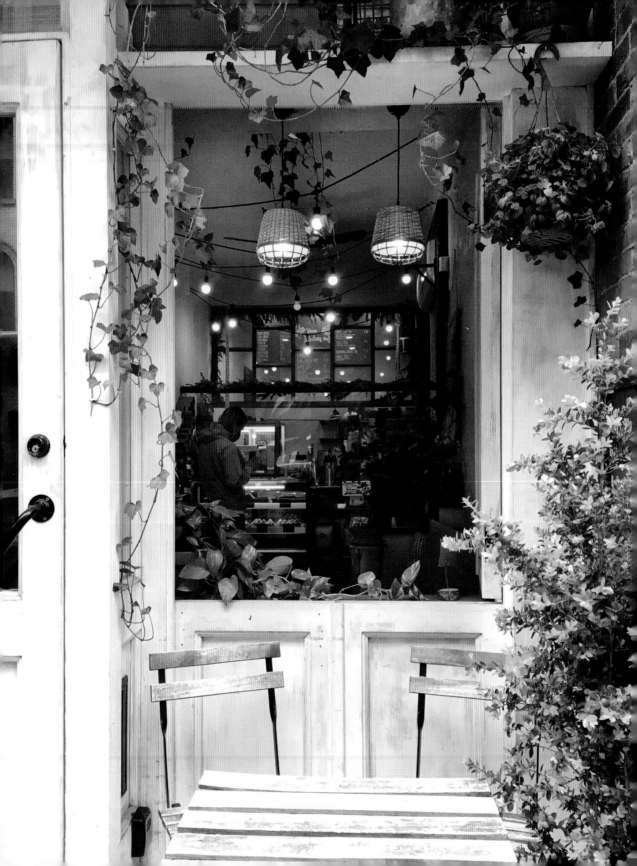

Introduction

When most people think of New York City, they imagine soaring skyscrapers, busy streets, and crowded sidewalks. *Charming* is not the adjective that usually comes to mind. But beyond the steel and glass of Midtown, the city has another side, one that is picturesque, a bit quieter, and—yes—seriously charming. The cobblestoned streets of SoHo, the ornate cast-iron verandas of Gramercy Park, and the elegant limestone townhouses of the Upper East Side are not only postcard-pretty; they reflect the history of this ever-evolving city in a way that never ceases to fascinate me. This is the New York I have always been drawn to.

I have lived in New York City almost all of my adult life, and for much of that time, like a true New Yorker, I would rush to work, hop on the subway to get from point A to point B, and never slow down long enough to notice the beauty all around me. Living in the heart of historic Greenwich Village, how could I have been so oblivious to the magnolia trees blooming in Washington Square Park, the enchanting ivy-covered townhouses on West 10th Street, and Grace Church (architect James Renwick Jr.'s French Gothic masterpiece) on Broadway?

On my travels outside New York, I always carried my "serious" Nikon camera and would shoot rolls and rolls of film. In new surroundings, I was like a kid in a candy store, trekking for miles, too inspired by my discoveries to feel any fatigue. But it took the magic of modern technology to focus my lens on my own city. Tracking my steps with a Fitbit pushed me to walk and explore more, carrying an iPhone meant I always had a camera on hand, and posting on Instagram provided a fun way to share and showcase my photos.

Urban Backyard, a a small, charming coffee shop on Mulberry Street in Nolita

For several years, I would wake up at the crack of dawn to walk before work, slowly expanding my route. Sometimes I traversed the West Village; other days I'd head uptown passing through Gramercy Park on my way to my Midtown office. I began to shoot what resonated with me: distinctive doors (#dooroftheday was a favorite hashtag), stylish storefronts, classic brownstones, architectural details, and pretty flower shops. Once I left my full-time job, I was happily free to spend even more time exploring and discovering my favorite corners of town.

Those are the neighborhoods I've chosen to include in this book. And no surprise, most are within walking distance of my Greenwich Village apartment: the East and West Villages, SoHo, NoHo, Nolita, Gramercy Park, and Murray Hill. Further afield, there's the Upper East Side, an area I'd often visit for work and museum-going, and Brooklyn Heights, a neighborhood that hooked me immediately with its leafy streets full of stunning historic architecture. And although there are many other charming and notable New York neighborhoods, it would be impossible to include them all in one book.

So, why this book? After I repeatedly heard from so many of my Instagram followers that they wished they could walk with me and see the city through my eyes, the idea of *Walk With Me: New York* was born. In addition to my favorite photos, I've included illustrated maps to highlight my favorite streets and have identified the location of each image, so fellow walkers can discover these gems for themselves.

I hope that my very personal and intimate portrait of New York City will speak to anyone who dreams of living in a beautiful brownstone or sitting at a Village café; to travelers and ex–city dwellers who have special memories of their time here; and to my fellow New Yorkers, who I hope will be inspired to look at the city we love with fresh eyes and newfound appreciation. Happy walking!

Susan Kaufman
New York City, 2021

OPPOSITE, CLOCKWISE FROM TOP LEFT: Quirky black doors on Gay Street; Roman and Williams Guild, Howard Street; LoveShackFancy, Bleecker Street; Jack's Stir Brew, West 10th Street

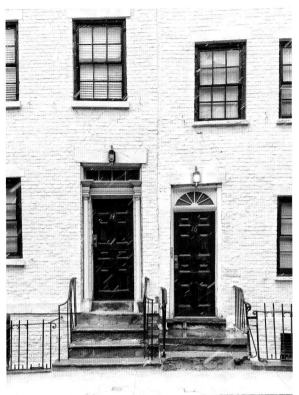
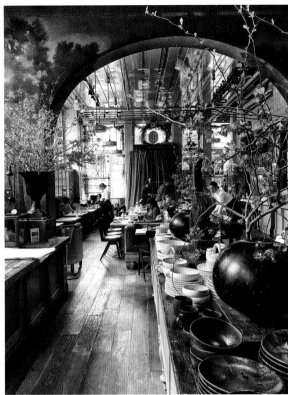
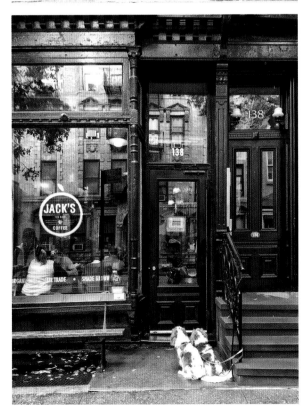
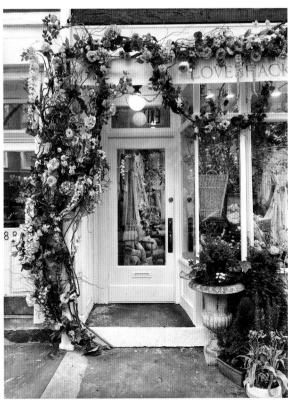

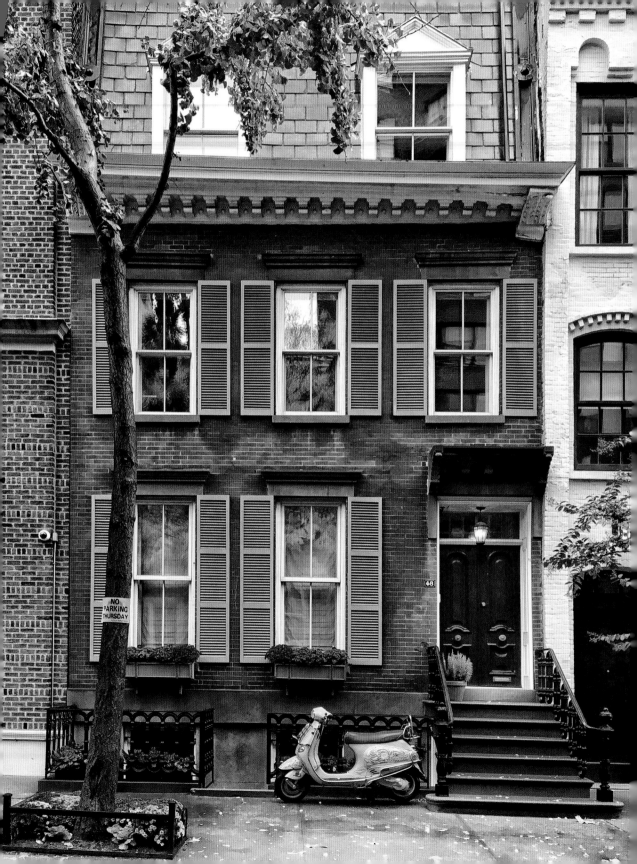

GREENWICH VILLAGE

How lucky am I to live in the middle of Greenwich Village? Very lucky indeed! Washington Square Park, with its iconic Stanford White–designed arch, is only a few short blocks from my front door. As I walk to the park, I can cut through Washington Mews, a private cobblestoned street filled with charming carriage houses. And strolling down 10th Street between 5th and 6th Avenues (the most beautiful block in New York, in my opinion) is like taking a walk through history: Mark Twain lived in number 4, poet Emma Lazarus in number 18, and artist Marcel Duchamp in number 28 (one of James Renwick Jr.'s "English Terrace Row" townhouses). It's an embarrassment of riches. I'm truly grateful to be surrounded by so much beauty in my daily life.

I've lived in the Village for many years, but even before I made my home here (always my dream), I spent a great deal of my childhood and young adulthood visiting my grandmother in her Greenwich Village apartment. I frolicked in the fountain in Washington Square Park, shopped for "groovy" shoes on 8th Street, heard jazz at Bradley's on University Place . . . I could go on and on. Suffice it to say that I'm intimately familiar with this neighborhood. And like so many New York neighborhoods, there have been quite a few changes here over the years. (I'm thankful that Il Cantinori, my favorite neighborhood restaurant—and the site of my engagement—is still going strong.) But while the Village might not be the bohemian or artistic capital it once was, the heart and soul of the Village is still beating, from the handsome nineteenth-century Greek Revival row houses of Edith Wharton's Washington Square North; to Cafe Wha?, Bob Dylan's early folk music venue on MacDougal Street; to Washington Square Park, still a mecca for students and free spirits. The Village will always be a New York treasure.

A perfectly color-coordinated Vespa matches a charming 1849 townhouse on West 10th Street.

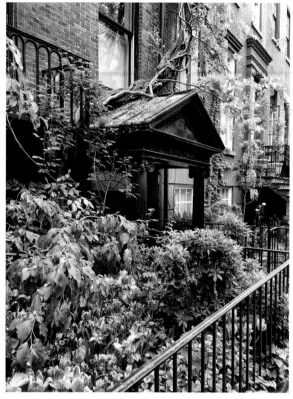
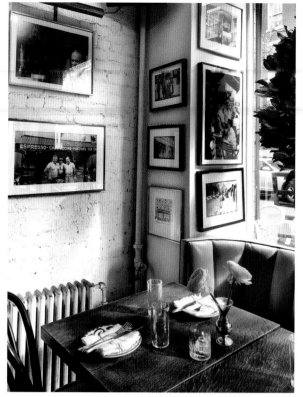
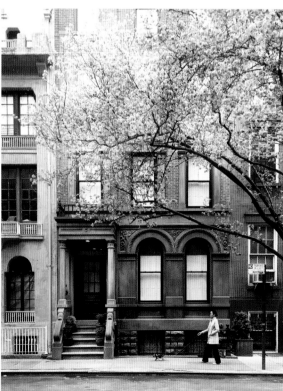
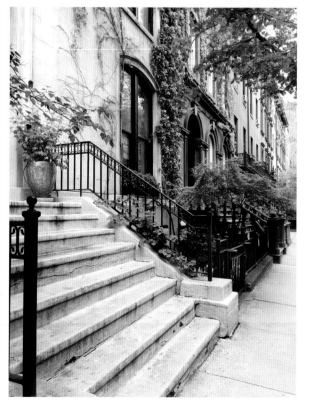

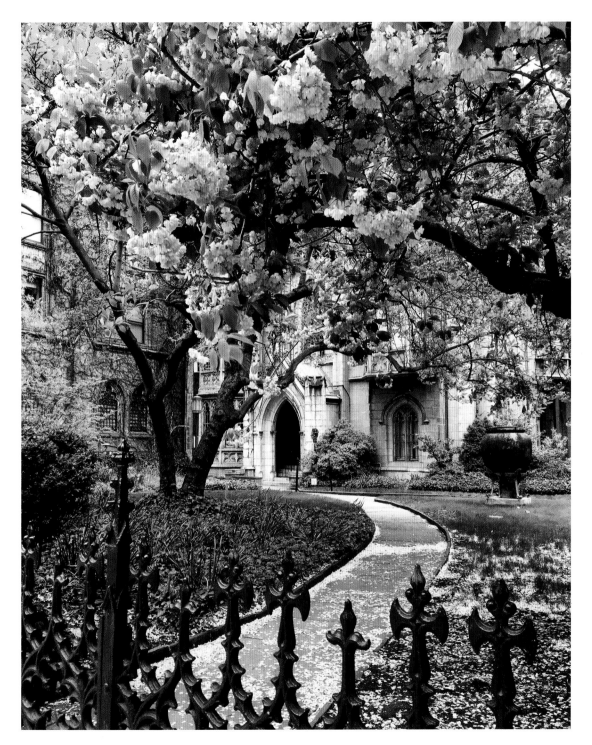

OPPOSITE, CLOCKWISE FROM TOP LEFT: Tulips in bloom on West 10th Street; Caffe Dante's old-world interior on MacDougal Street; a touch of greenery on West 10th Street; a handsome brownstone on Waverly Place **ABOVE:** Grace Church's beautiful Gothic rectory on Broadway and East 10th Street is partially hidden by cherry blossoms.

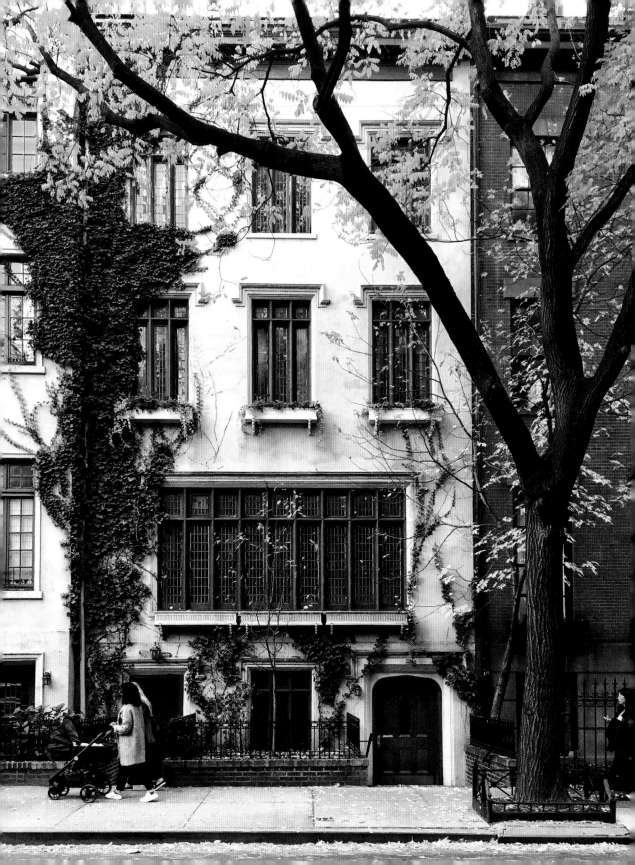

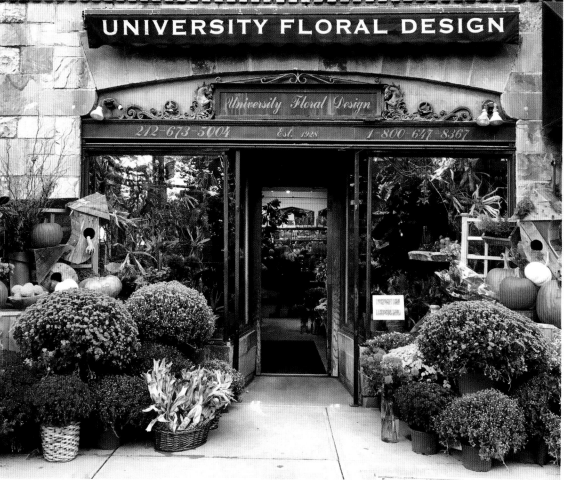

OPPOSITE: Strollers pass by a stunning West 9th Street facade. **ABOVE:** University Floral Design's striking storefront display on University Place

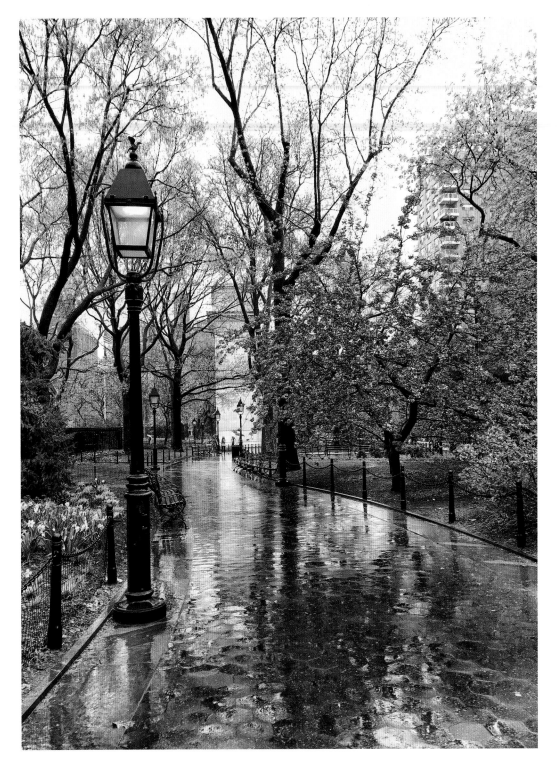

ABOVE: Cherry tree blooms brighten up a rainy day in Washington Square Park.
OPPOSITE: Neighborhood favorite Il Cantinori's picturesque canopy and planters on East 10th Street

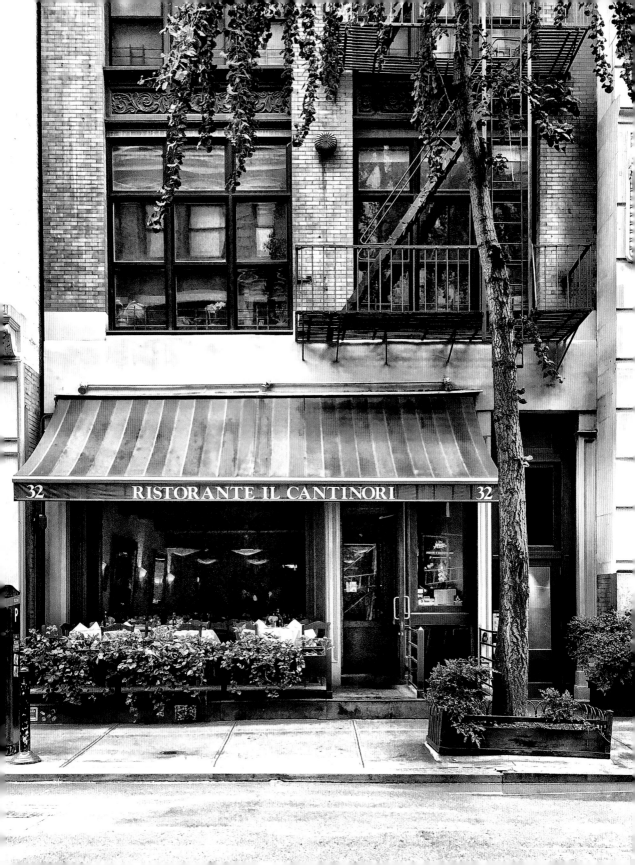

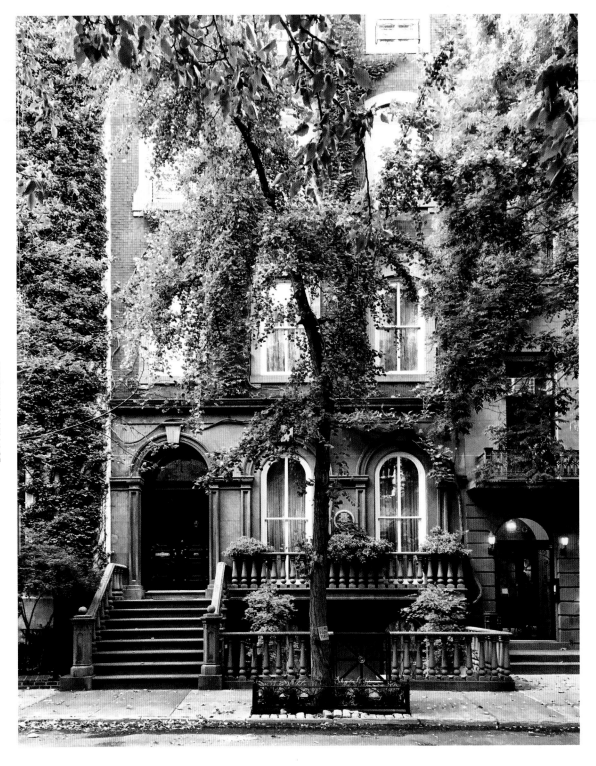

ABOVE: This beautiful West 10th Street Italianate-style townhouse (ca. 1856) was once home to poet Emma Lazarus. **OPPOSITE:** West 10th Street's golden leaf–strewn brick sidewalk

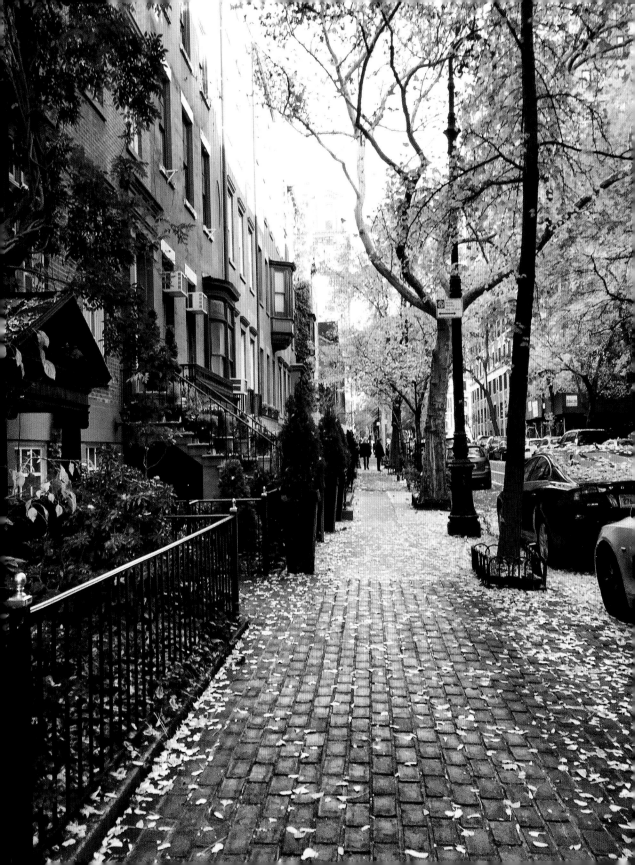

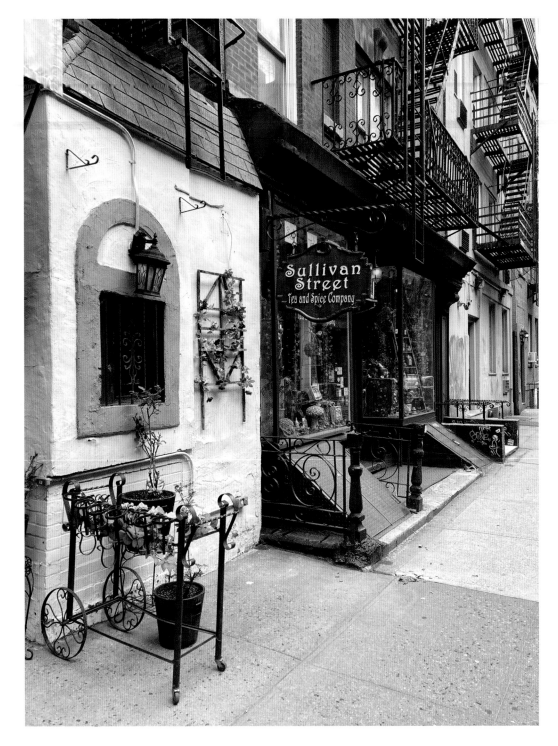

ABOVE: Sullivan Street Tea and Spice Company's fanciful shopfront and cute cart bring old-school charm to Sullivan Street. **OPPOSITE, CLOCKWISE FROM TOP LEFT:** A fun mix of doorways on Sullivan Street between Bleecker and Houston Streets includes juliette balconies, colorful facades, and elegant arches.

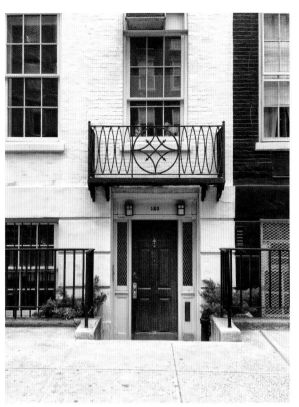
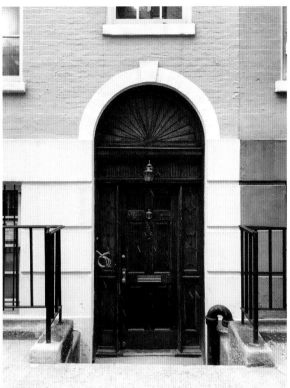
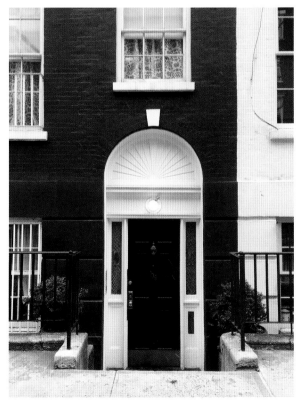
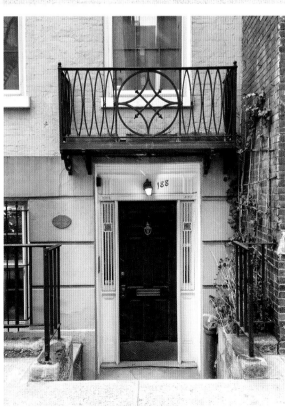

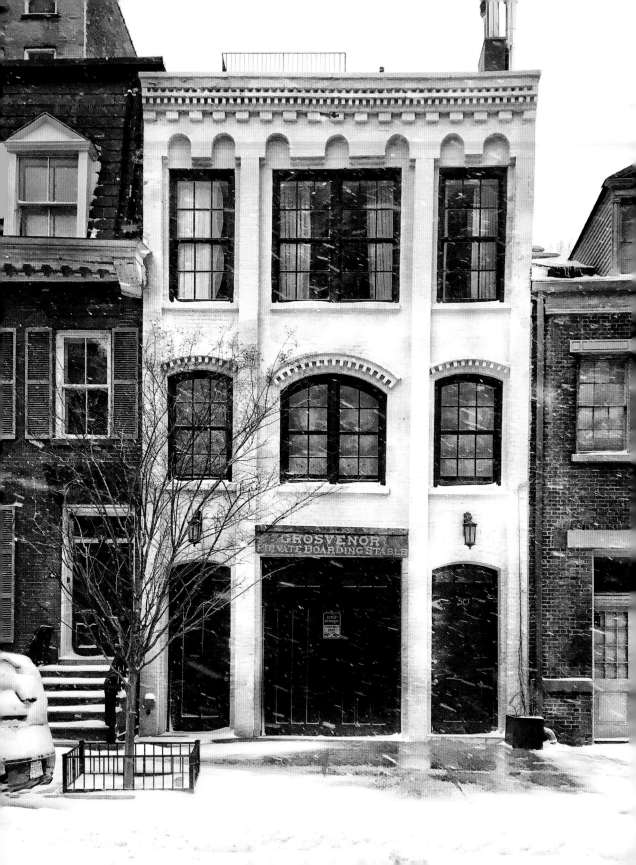

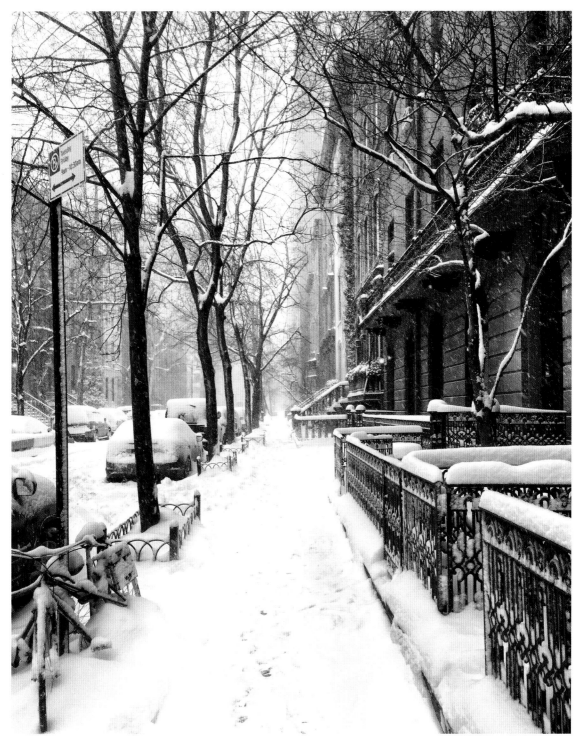

OPPOSITE: This handsome former stable on West 10th Street was converted to a private home in 1887. Playwright Edward Albee lived here in the 1960s. **ABOVE:** A snow-covered row of architect James Renwick Jr.'s elegant townhouses on West 10th Street

ABOVE: This diminutive gray building on East 13th Street was once the publishing house of writer Anaïs Nin. **OPPOSITE, CLOCKWISE FROM TOP LEFT:** MacDougal Street's colorful facades; lavender shutters in quaint Washington Mews; room for a Vespa on West Washington Place; cottage charm in Washington Mews

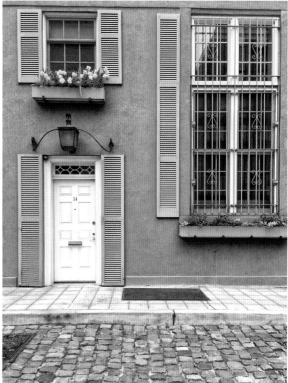
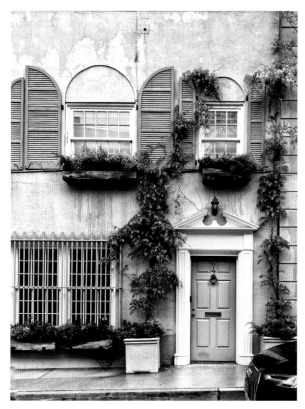
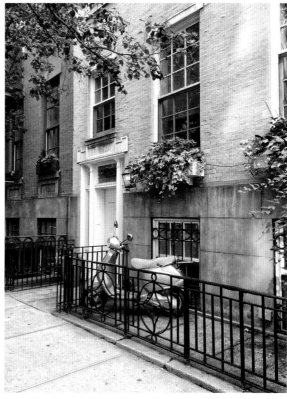

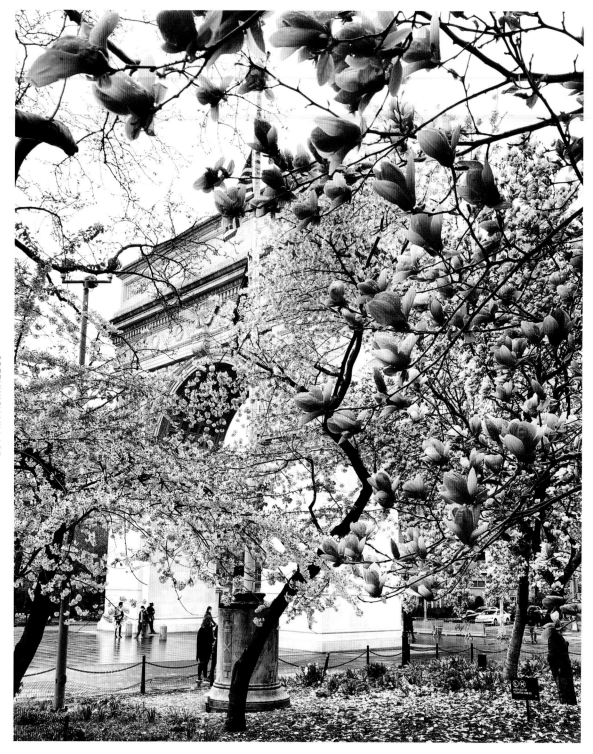

ABOVE: A glimpse of the iconic Washington Square Arch from behind pretty magnolia and cherry blossoms

My Favorite Streets

GREENWICH VILLAGE

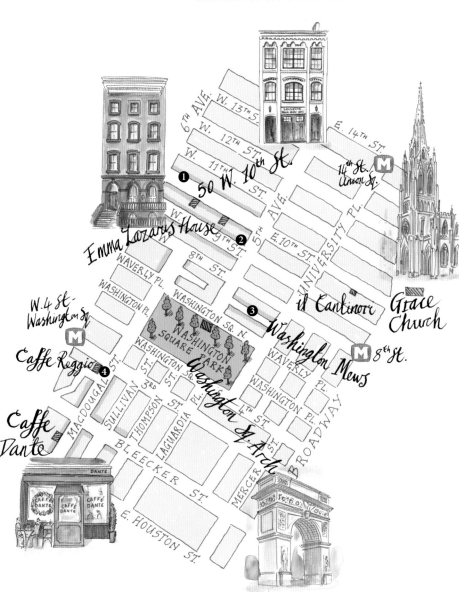

❶ W. 10th Street
My absolute favorite block in New York. Beautiful historic townhouses line both the north and south sides of the street between 5th and 6th Avenues.

❷ W. 9th Street
The townhouses between 5th and 6th Avenues are always striking, but especially when decorated for the winter holidays.

❸ Washington Mews
A unique block of charming two-story carriage houses between University Place and 5th Avenue

❹ MacDougal Street
There are charming cafés and colorful facades between West 3rd and Houston Streets.

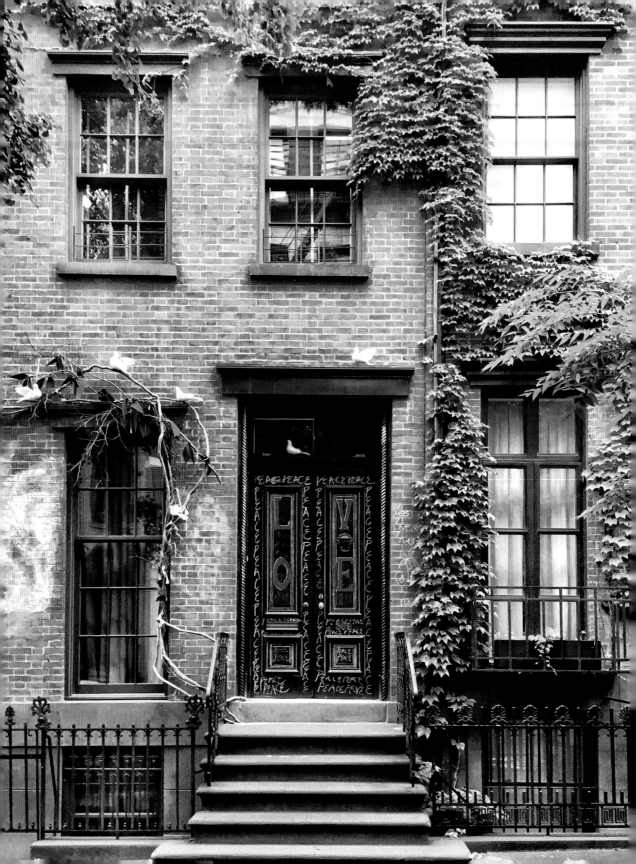

WEST VILLAGE

For pure charm and history, nothing beats the West Village. It is my absolute favorite neighborhood to wander and shoot. In fact, editing my photos for this section was by far the most challenging—they could be a whole book on their own!

Part of the neighborhood's unique appeal is its quirky layout. Unlike the rest of Manhattan, where streets adhere to an organized grid system, the West Village is still laid out according to its original eighteenth-century plan. As you meander through the winding, tree-lined streets of this mostly residential neighborhood, it feels like a tranquil escape from bustling Manhattan. It's also really, really easy to get lost. But losing oneself among the handsome brick Federal houses, classic brownstones, hidden courtyards, shops, and restaurants is part of the fun.

My morning routine for the past few years has been to head west from my East 10th Street apartment to grab a coffee at Jack's Stir Brew on 10th Street between Greenwich Avenue and Waverly Place. From there I can never resist checking out the wonderful Three Lives & Co. bookstore half a block away, followed by a stroll around the neighborhood.

And every time I'm exploring this enclave, on the lookout for a beautifully decorated stoop, or a stylish new shopfront, or a townhouse I've never noticed, I silently thank the New York City Landmarks Preservation Commission for saving the old-world character of the village by designating more than fifty blocks of it as a historic district in 1969. The West Village boasts the largest concentration of early New York residential architecture in all five boroughs, and changes to facades must adhere to the aesthetics of the building. Redevelopment is extremely limited.

So many of the country's important and cultural movements—from gay rights to experimental theater—got their start here, and the list of writers, poets, musicians, and actors who have called the West Village home is endless. With informational plaques on so many buildings, I always have fun uncovering more of its history while I roam.

A "love"ly creative and eye-catching door on West 4th Street between Bank and West 12th Streets

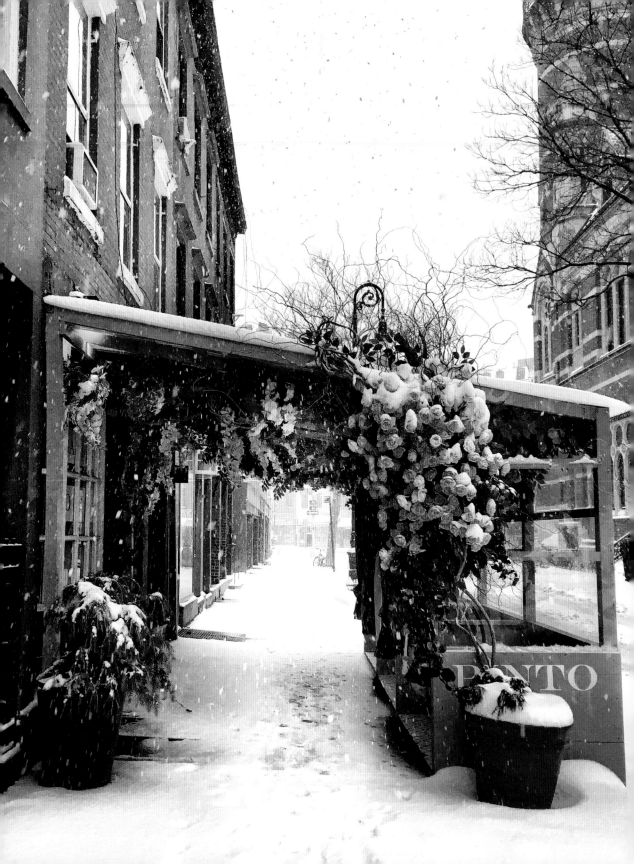

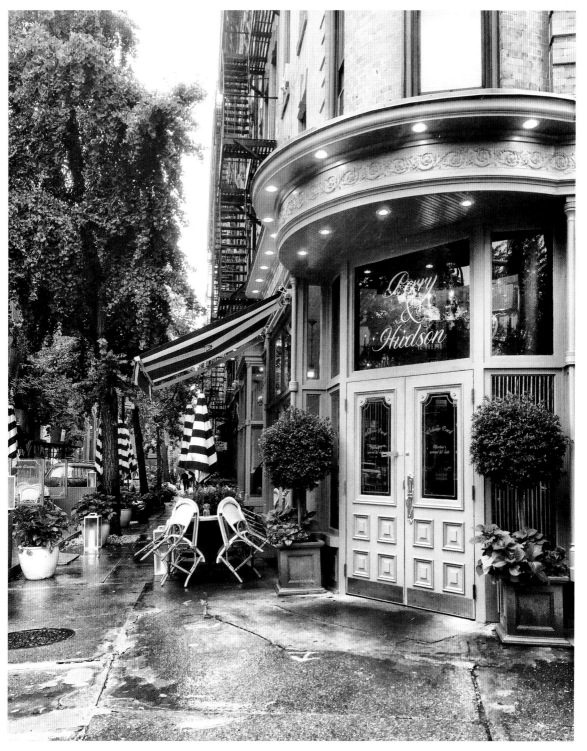

OPPOSITE: An unexpected combination of snow and faux roses on West 10th Street **ABOVE:** Dante West Village, a charming café on the corner of Perry and Hudson Streets, is inviting even on a rainy day.

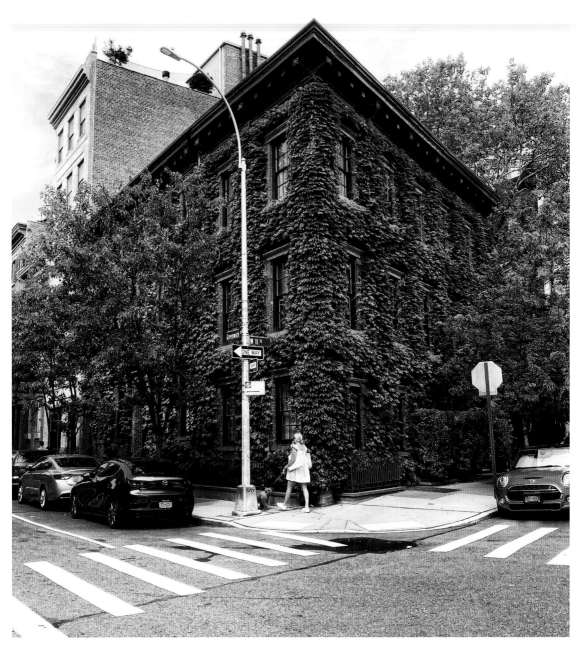

ABOVE: A private home on Greenwich and West 11th Streets covered in lush greenery
OPPOSITE, CLOCKWISE FROM TOP LEFT: Commerce and Bedford Streets; Gorjana jewelry shop on West 4th Street; Gay Street; historic wood frame house (ca. 1822) on Grove Street

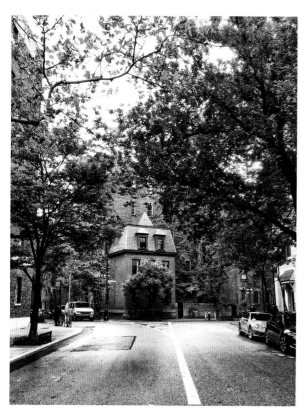
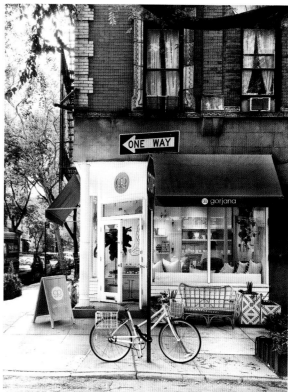
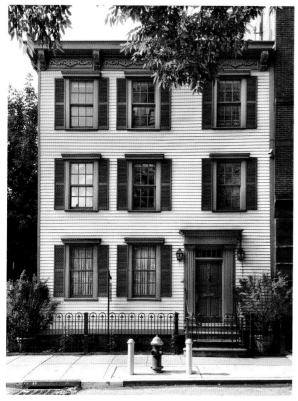
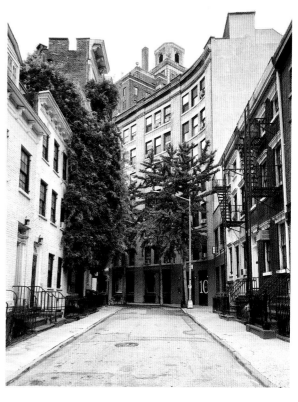

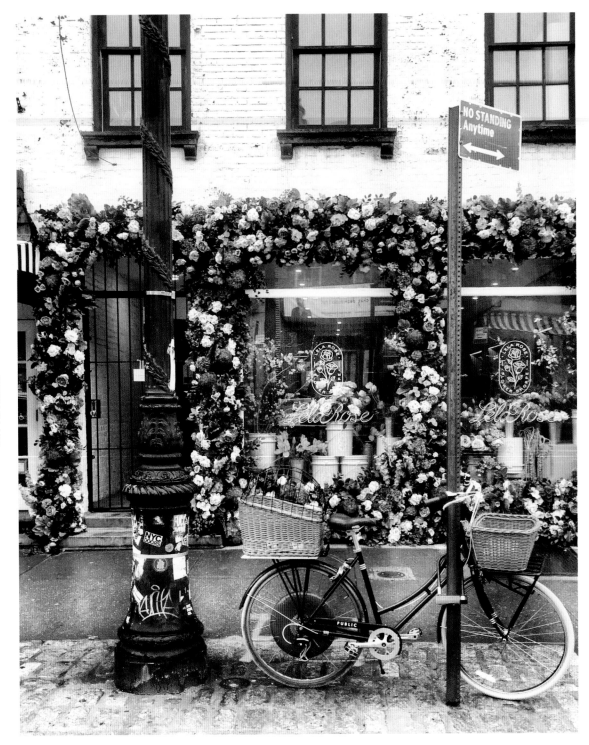

ABOVE: A pop-up shop's beautiful floral installation brings a touch of romance to Greenwich Avenue. **OPPOSITE:** Left Bank Books, a wonderful old-school shop for rare and used books on Perry Street

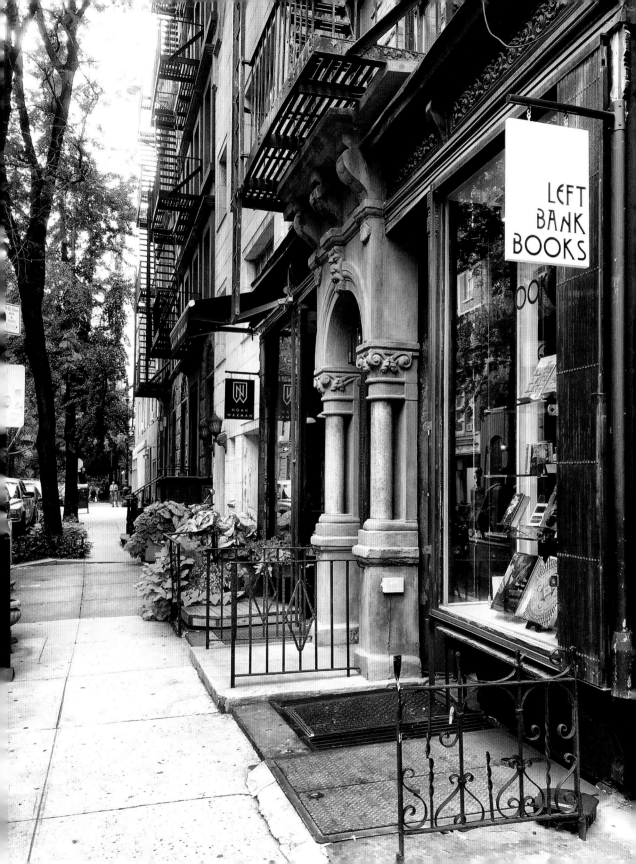

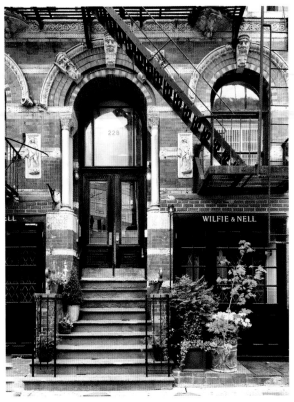

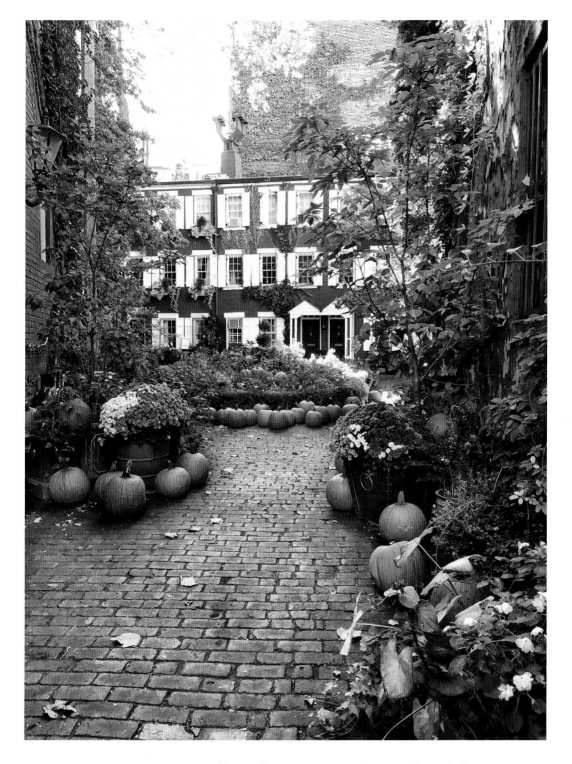

OPPOSITE, CLOCKWISE FROM TOP LEFT: Wilfie & Nell restaurant, West 4th Street; John Derian's Christopher Street shop; fall leaves on West 11th Street; Petite Boucherie, corner of Christopher and Gay Streets **ABOVE:** Historic Grove Court's annual pumpkin display

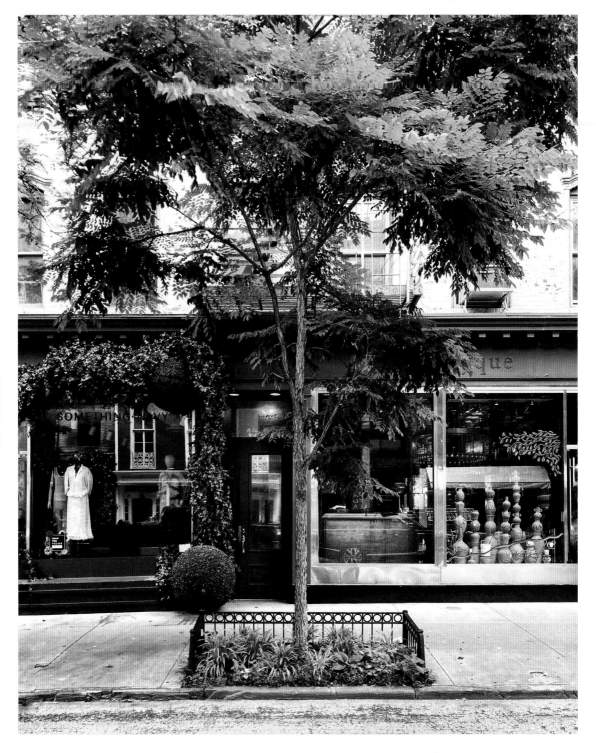

ABOVE: Creatively decorated storefronts on Bleecker Street between Perry and Charles Streets
OPPOSITE: Sogno Toscano, a charming coffee shop and Italian grocery store on the corner of Perry Street and Waverly Place

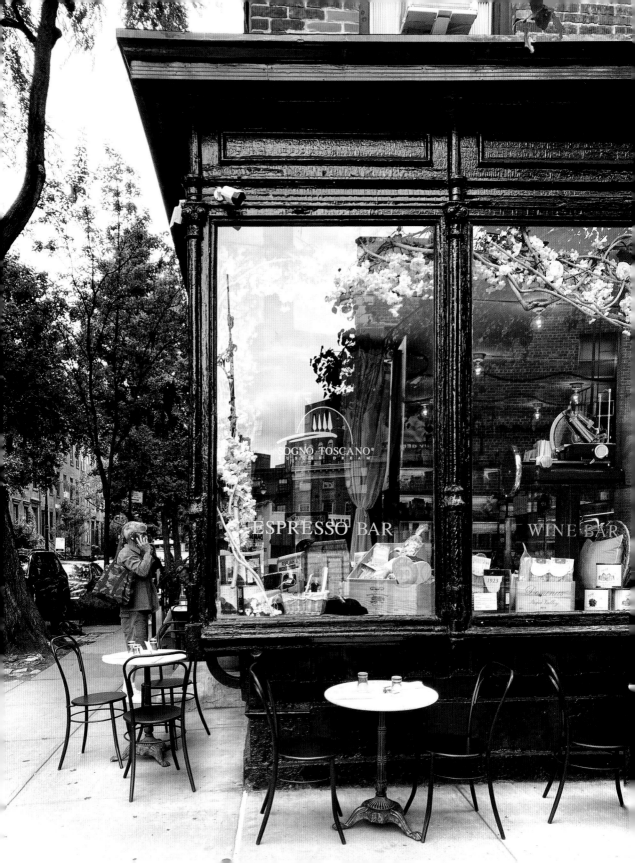

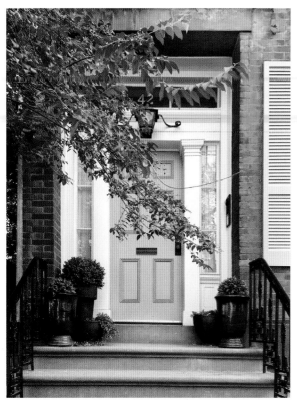
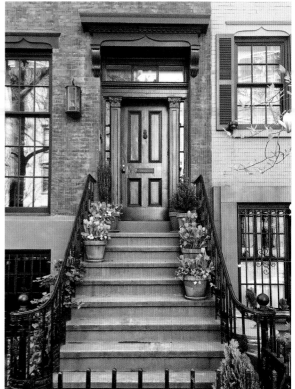
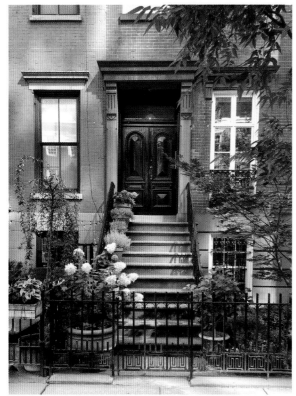
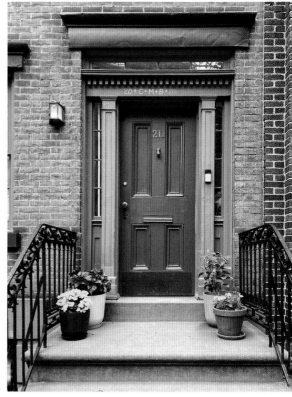

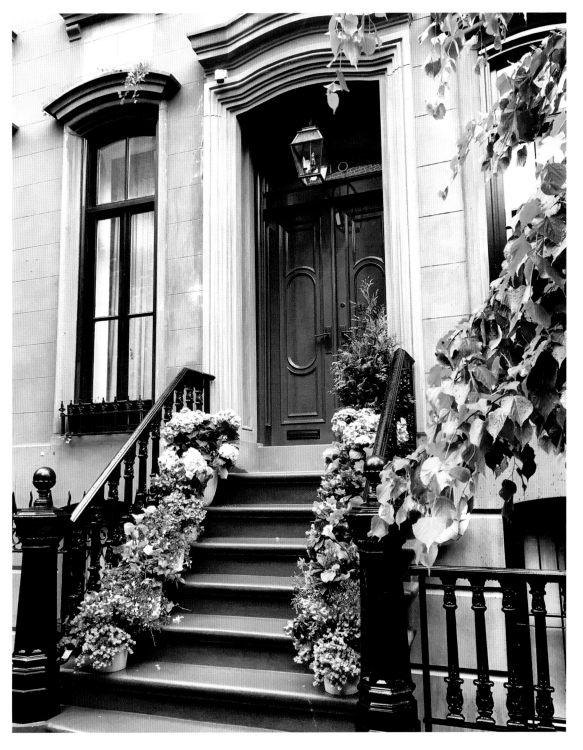

OPPOSITE, CLOCKWISE FROM TOP LEFT: A roundup of lovely stoops and doors on Jane, Bank, West 11th, and West 13th Streets **ABOVE:** A pretty flower-bedecked stoop and chic aubergine door on West 11th Street

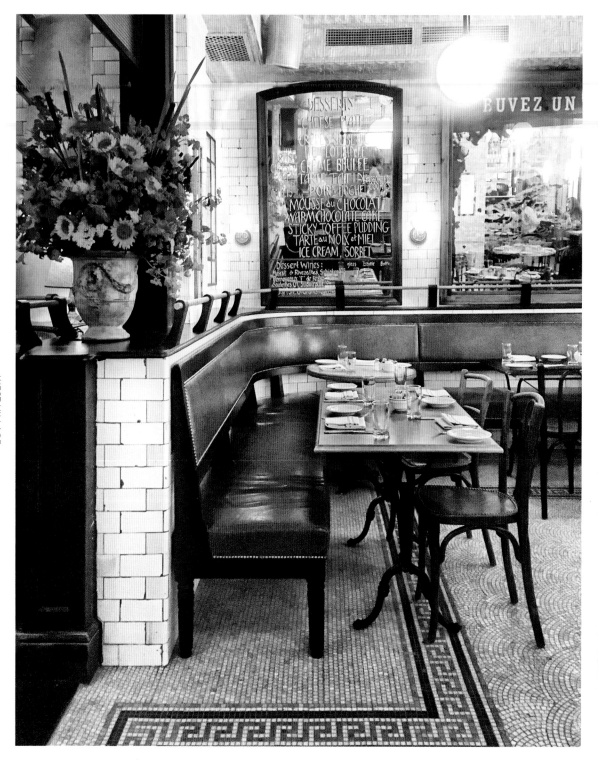

ABOVE: A cozy banquette and bright sunflowers at Pastis, a classic French bistro on Gansevoort Street
OPPOSITE: An early-1800s brick building on the corner of Waverly Place and West 11th Street

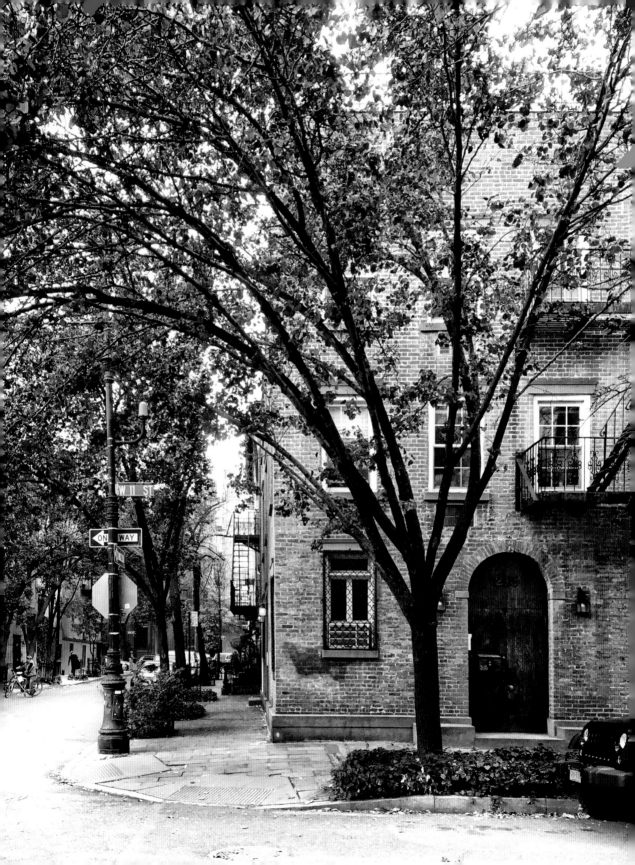

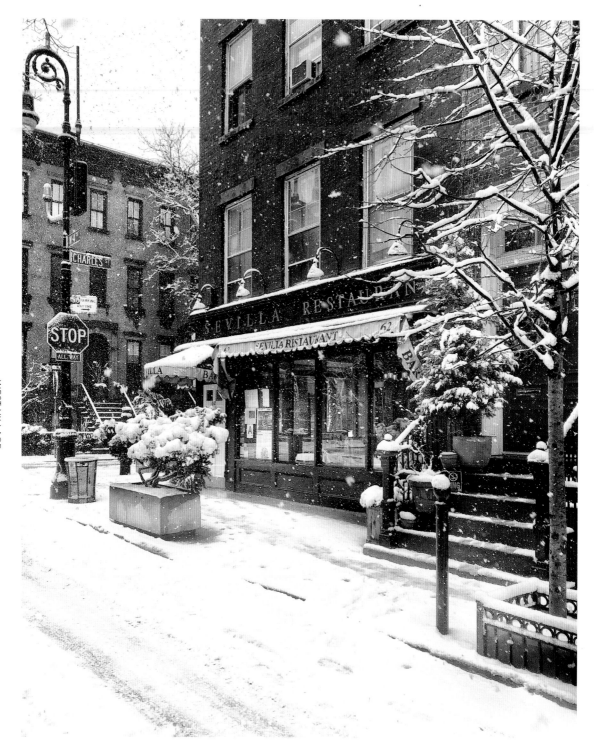

ABOVE: Spanish restaurant and long-standing neighborhood favorite Sevilla on Charles Street
OPPOSITE, CLOCKWISE FROM TOP LEFT: Decorated Bank Street stoop; the Cherry Lane Theatre on winding Commerce Street; Sant Ambroeus restaurant, West 4th Street; Gay Street, facing north

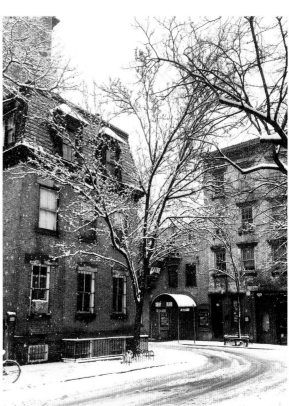
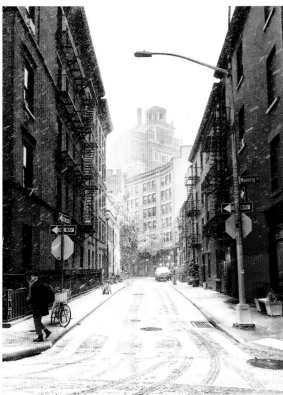
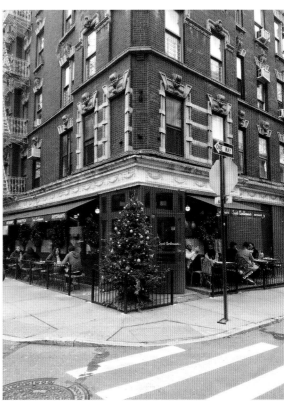

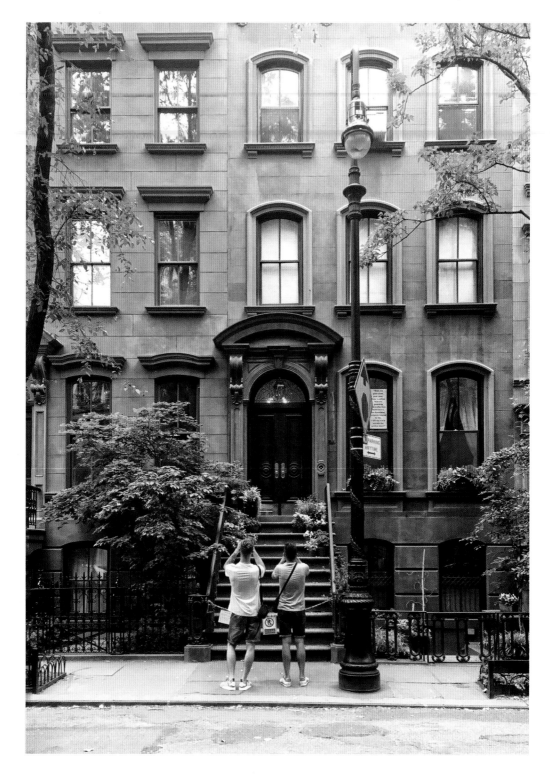

ABOVE: A classic brownstone and fan favorite on Perry Street (Carrie Bradshaw's *Sex and the City* apartment facade)

My Favorite Streets

WEST VILLAGE

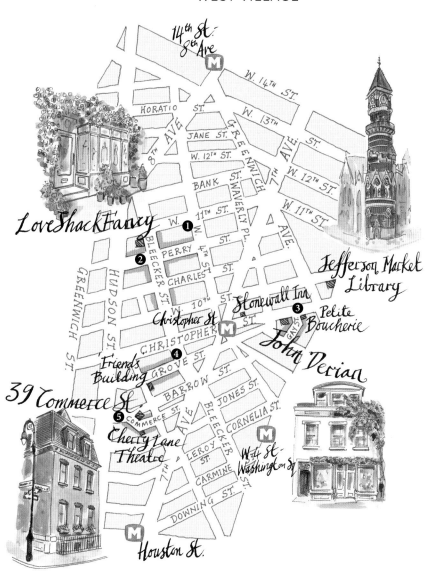

❶ Perry Street
The block between West 4th and Bleecker Streets tops my list for the prettiest townhouses.

❷ Bleecker Street
The most creative and eye-catching shopfronts are between Bank and Perry Streets.

❸ Gay Street
A short and narrow historic block, and one of the Village's most photographed

❹ Grove Street
The two blocks between Bleecker and Hudson Streets include two lovely restaurants, Little Owl and Buvette, the *Friends* apartment facade, and historic Grove Court.

❺ Commerce Street
A winding block between Bedford and Barrow where you'll find the Cherry Lane Theatre and the handsome "Twin Houses" (ca. 1831)

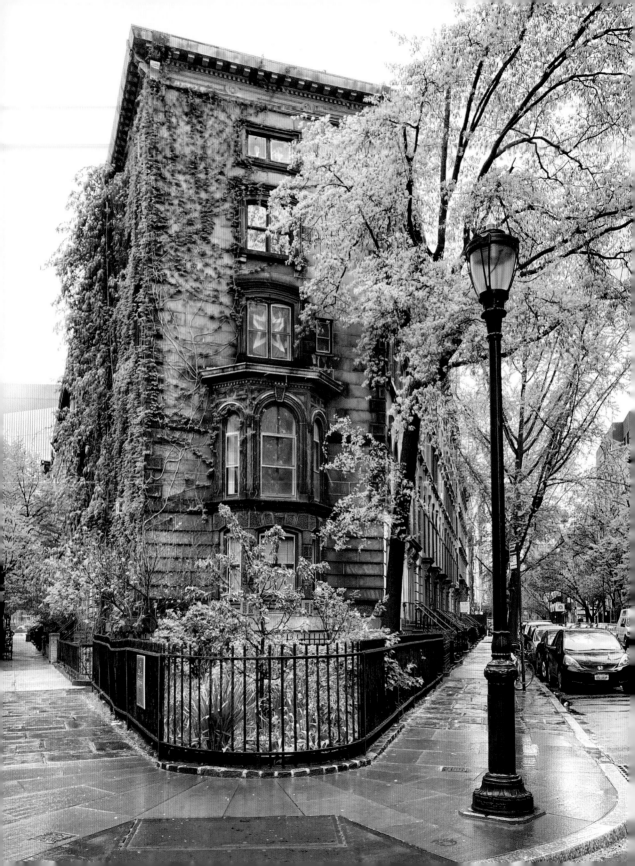

EAST VILLAGE

I like to think of the East Village as the West Village's wild little sister—edgier, less polished, but a lot of fun. The neighborhood is, obviously, quite a bit grittier than it was when Peter Stuyvesant, the Dutch governor of New Amsterdam, purchased three hundred acres of farmland and built his home on 10th Street in 1650. But there is still plenty of historic charm here, especially on his namesake Stuyvesant Street and on 10th Street between 2nd and 3rd Avenues.

These two quiet blocks, however, are atypical for this neighborhood. When you cross over 2nd Avenue heading east, you start to experience the livelier, funkier East Village. This is the village of my early New York days: cheap, delicious eateries on St. Marks Place; drinks with friends at dive bars; dancing at clubs along Avenue A. (Those were the Madonna *Desperately Seeking Susan* days.) Many of those bars and clubs are long gone, and the art, beatnik, hippie, and punk scenes are mostly history. But even with the gentrification of the past two decades, the neighborhood has still managed to keep much of its cool, youthful spirit. With so many indie shops, vintage clothing stores, and hip bars and restaurants, the East Village is still a place I love to explore. Where else could you find a Korean fried chicken restaurant (MonoMono) combined with a stylish flower shop (Le Bouquet)?

The East Village has always been a melting pot, and echoes of its immigrant past can be found in its original tenement buildings. From the first German immigrants who arrived in the 1800s to the eastern European Jews, Irish, Poles, Ukranians, and Puerto Ricans who came later, the neighborhood still has a vibrant mix of people and cultures. What could be more New York than that?

A charming wisteria-covered building on the corner of Stuyvesant and East 10th Streets on a rainy spring day

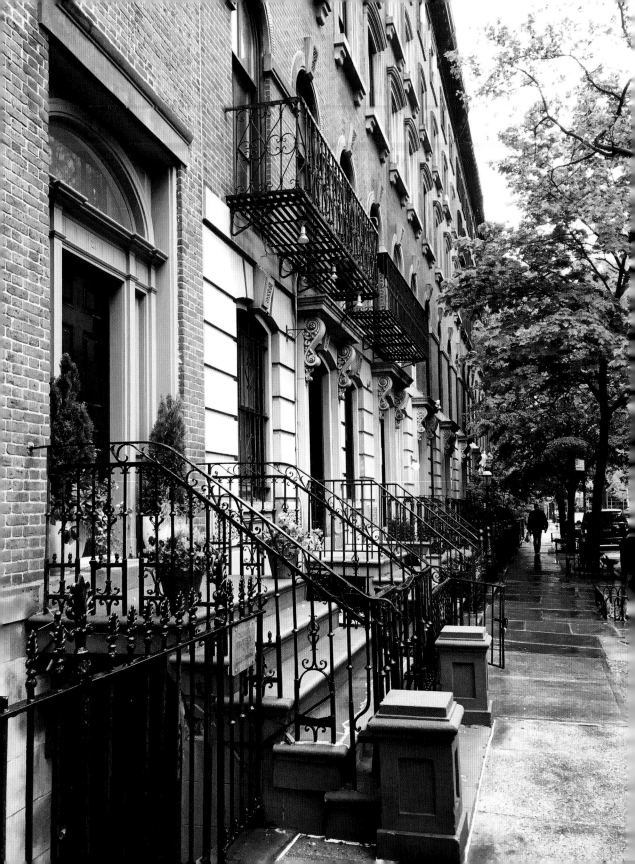

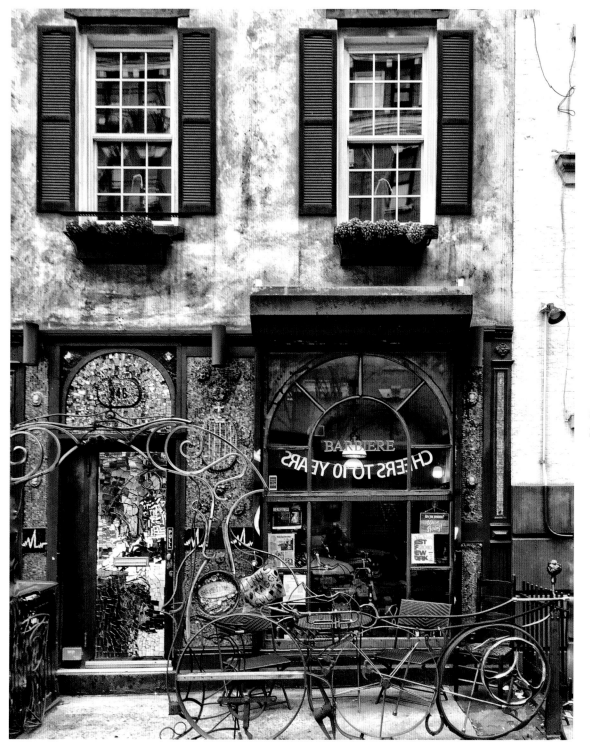

OPPOSITE: Stuyvesant Street, one of the oldest blocks in Manhattan, facing east toward 2nd Avenue
ABOVE: Barbiere's unique vintage barbershop on East 5th Street

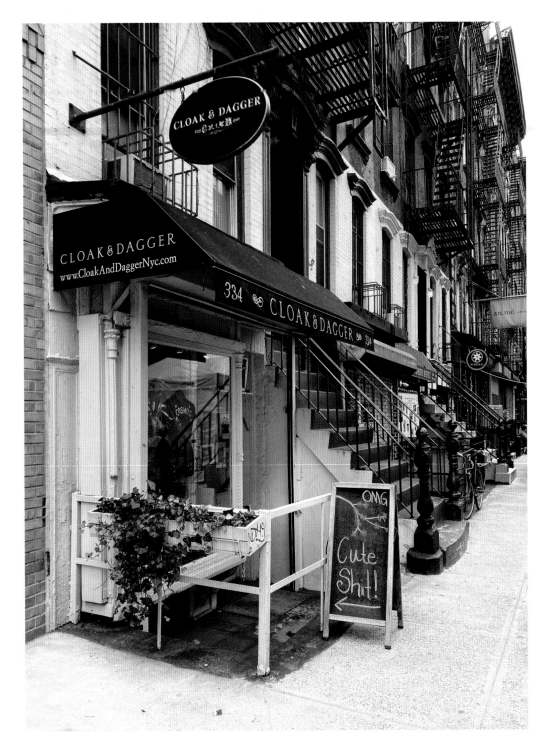

ABOVE: Cloak & Dagger's cute vintage clothing store on East 9th Street
OPPOSITE, CLOCKWISE FROM TOP LEFT: Stranded Records, East 5th Street; Niconeco Zakkaya, a Japanese stationery store on East 10th Street; 9th St. Vintage, on East 9th Street; Cobblestones vintage clothing shop, East 9th Street

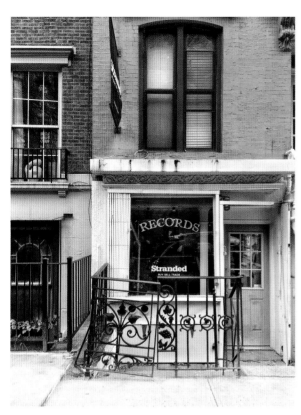
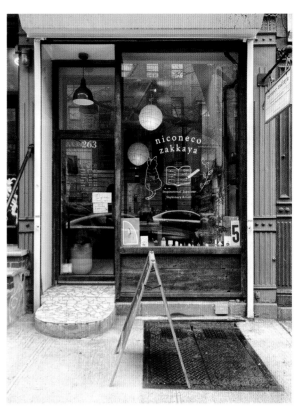
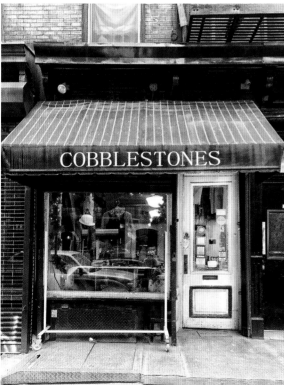
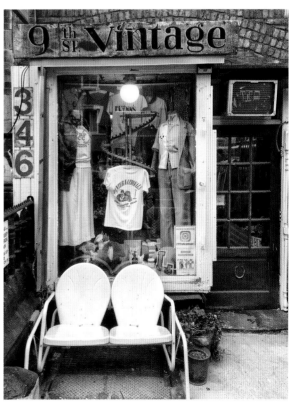

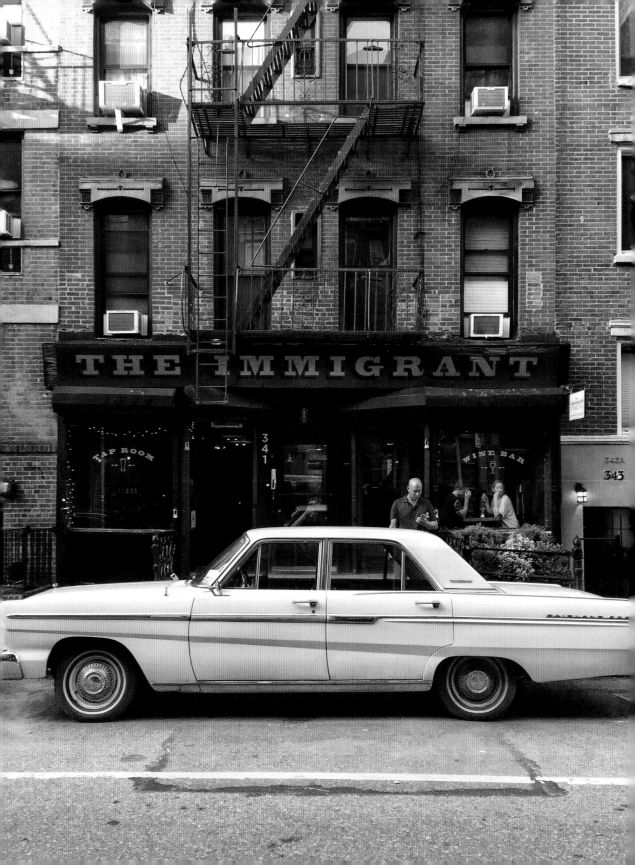

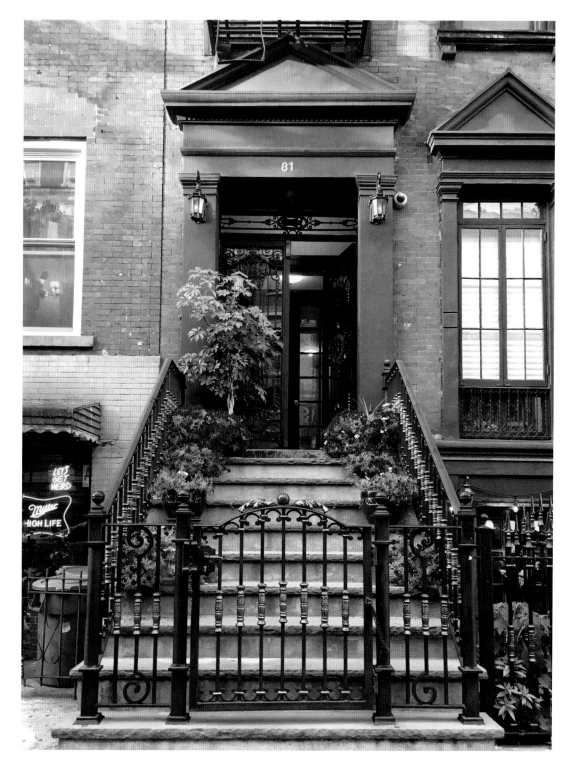

OPPOSITE: The Immigrant, a beer and wine bar in a former tenement building on East 9th Street
ABOVE: A historic 1841 townhouse's flower-decorated stoop on East 7th Street

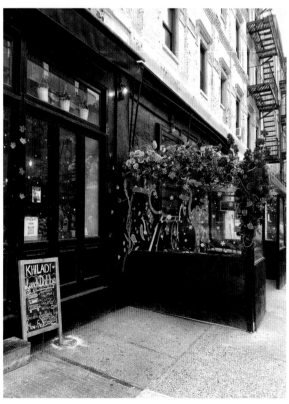

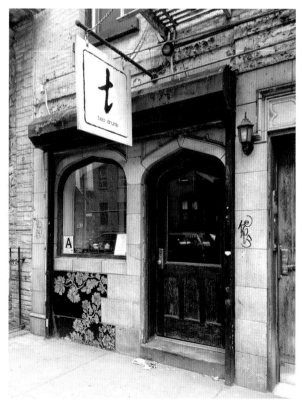

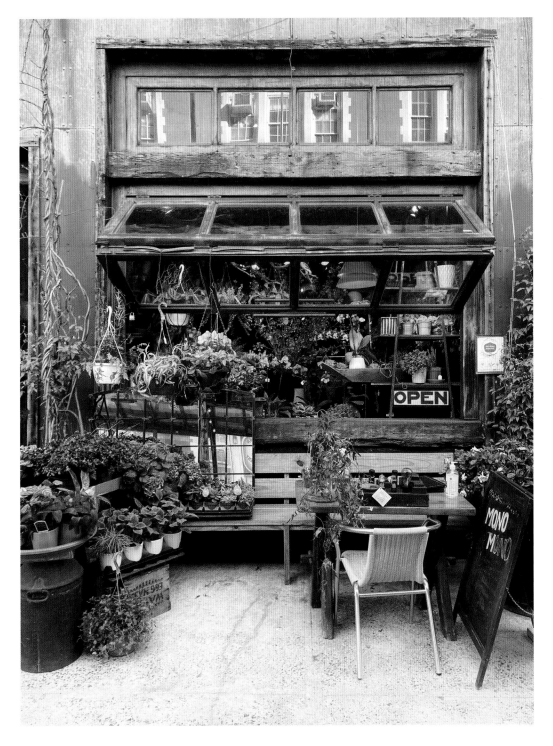

OPPOSITE, CLOCKWISE FROM TOP LEFT: Italian restaurant Gemma's rustic interior in the Bowery Hotel; John Derian's home decor shop on East 2nd Street; Tea Drunk, a tea-tasting shop on East 7th Street; Indian restaurant Khiladi on Avenue B **ABOVE:** Florist Le Bouquet and Korean restaurant MonoMono's eye-catching storefront on East 4th Street

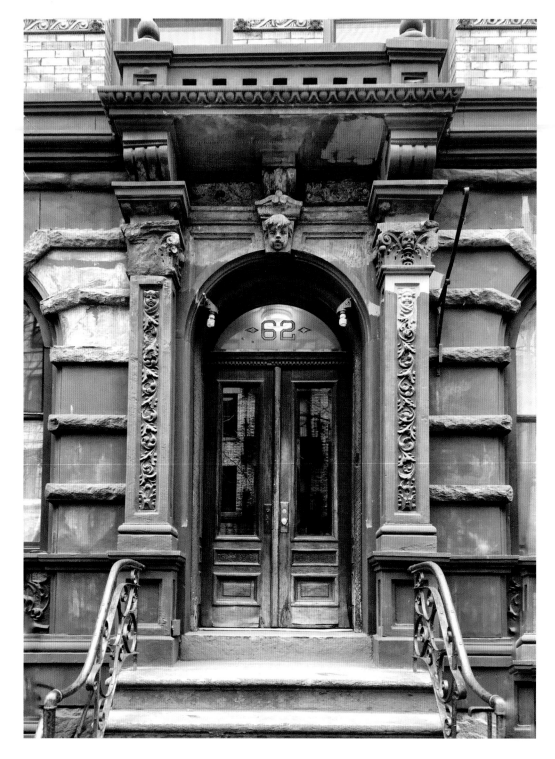

ABOVE: A wonderful mix of colors, textures, and architectural details on an East 7th Street entrance **OPPOSITE, CLOCKWISE FROM TOP LEFT:** A few charming architectural embellishments found throughout the neighborhood

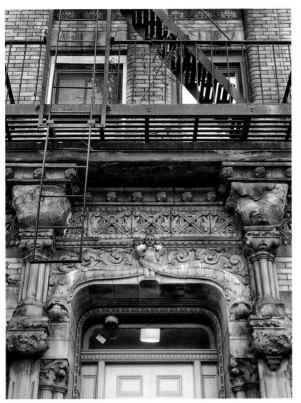
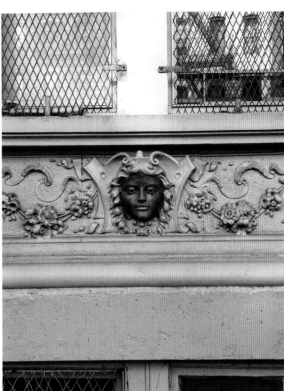
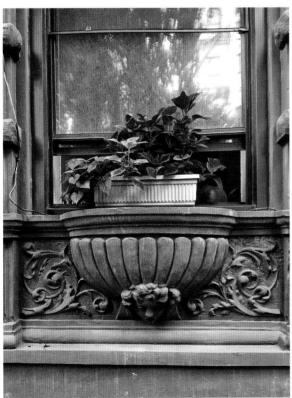
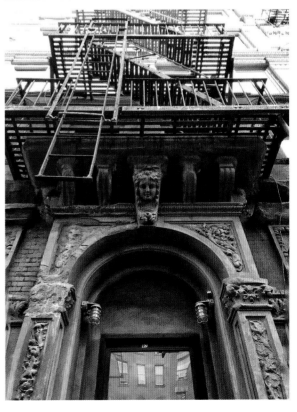

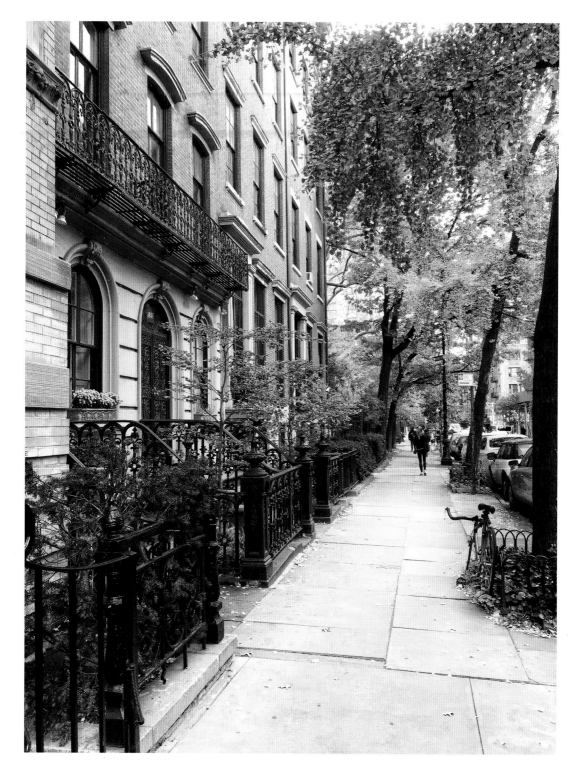

ABOVE: An autumn stroll past a graceful wrought-iron balcony and fence on East 10th Street between 2nd and 3rd Avenues

My Favorite Streets

EAST VILLAGE

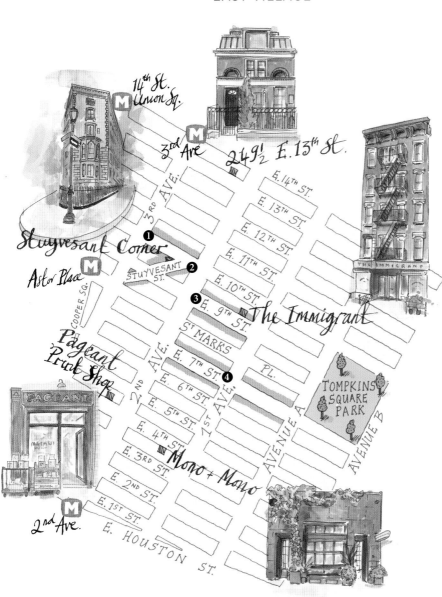

❶ E. 10th Street
A pretty tree-lined block of 1856 row houses between 2nd and 3rd Avenues, capped off by historic St. Mark's Church

❷ Stuyvesant Street
One of the oldest and most picturesque streets in New York, with my favorite corner building in every season

❸ E. 9th Street
The block between 1st and 2nd Avenues is filled with charming indie shopfronts.

❹ E. 7th Street
Two fun blocks of eclectic restaurants and shopfronts between 2nd Avenue and Avenue A

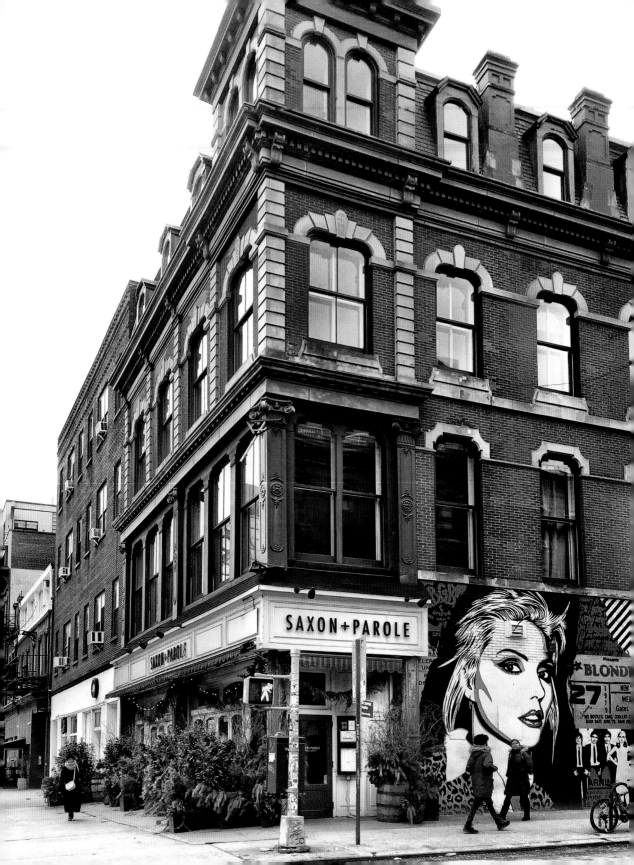

NOHO & NOLITA

NoHo (North of Houston) and Nolita (North of Little Italy) were relatively sleepy neighborhoods until the late 1990s, when stylish cafés and shops began to move in. Real estate agents—playing off SoHo's moniker—thought the new names would add cachet to the newly hip area, where rents were quickly rising. (The boundaries of both neighborhoods are still a bit murky.) NoHo, a tiny area spanning only a few blocks, was originally part of the East Village, while Nolita was always considered part of Little Italy. Once filled with traditional bakeries, churches, and Italian butchers (Albanese Meats & Poultry on Elizabeth Street is the lone survivor), Nolita is now a go-to destination for all things stylish. I really love the distinctly European vibe of so many of the boutiques and cafés.

Elizabeth Street boasts not only wonderful shops, but also the Elizabeth Street Garden, a favorite of mine to visit for its whimsical and unique mix of sculptures and architectural artifacts. It's a tranquil spot in the middle of a busy neighborhood.

While both areas have evolved, echoes of their past still remain. In NoHo, on cobblestoned Bond Street between Lafayette and Bowery (a landmarked block and one of NYC's most architecturally significant), you can find an elegant, recently restored 1884 white cast-iron building at number 54. (It now houses luxury condominiums and a Billy Reid store.) Number 24, constructed in 1893, was owned by famed photographer Robert Mapplethorpe in the 1970s; the Gene Frankel Theatre has occupied the street level since the 1940s, and in 1998 a dozen whimsical dancing gold statues by sculptor Bruce Williams were added to the exterior. The Smile, one of my favorite restaurants, at number 26, is below street level in a handsome brick mansion from 1831. That's a lot of history for one small block!

A mural of Blondie's Deborah Harry by Shepard Fairey adds a modern touch to an Italianate-style building (ca. 1868) on the corner of Bowery and Bleecker Streets.

ABOVE: Marché Maman's festive holiday pop-up shop on Centre Street **OPPOSITE, CLOCKWISE FROM TOP LEFT:** Ceci Cela Patisserie on Delancey Street; Bond Street's Smile restaurant; Le Labo perfumery on Elizabeth Street; Lafayette Grand Café & Bakery's interior on Lafayette Street

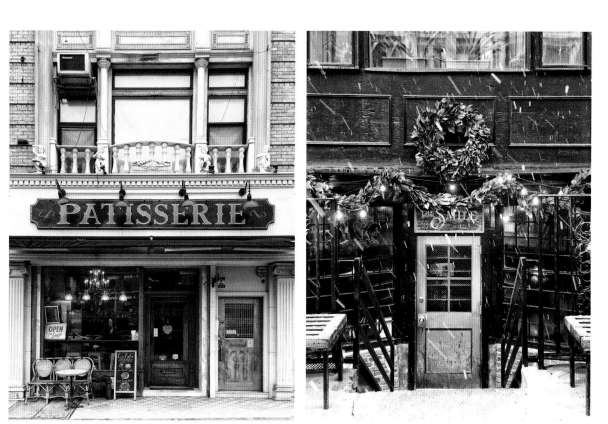

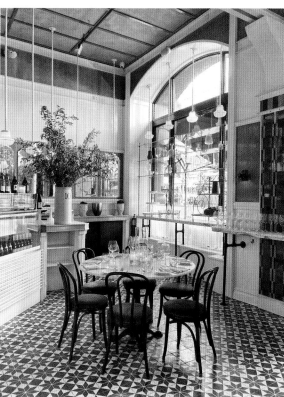

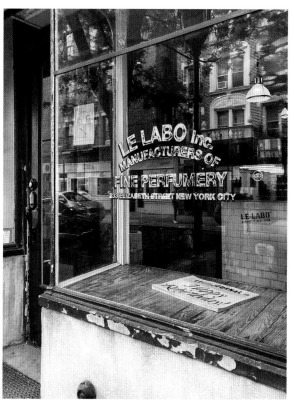

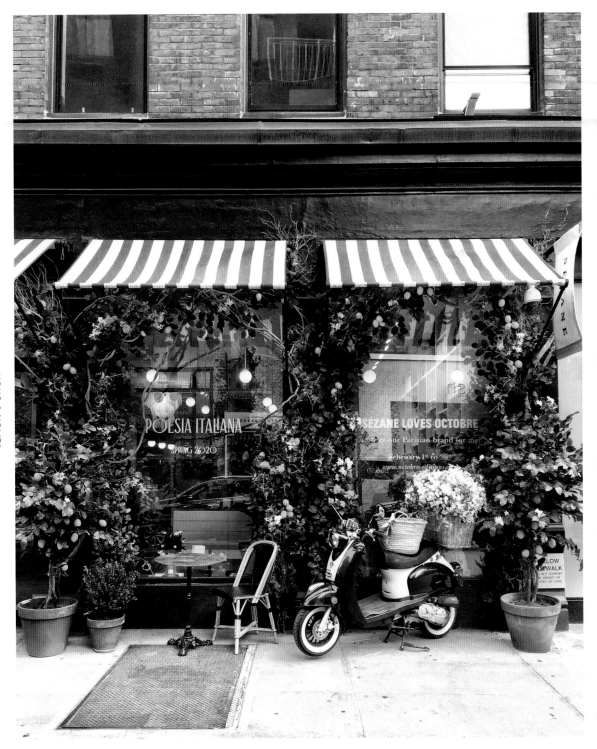

ABOVE: French retailer L'Appartement Sézane's eye-catching ode to Capri and all things Italian on Elizabeth Street **OPPOSITE:** Historic French candlemaker Cire Trudon's handsome shopfront, also on Elizabeth Street

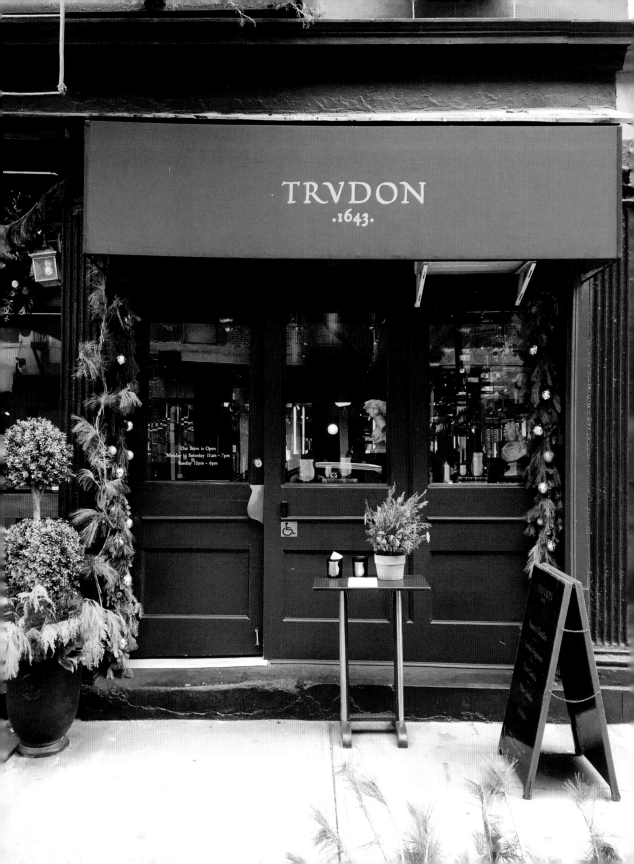

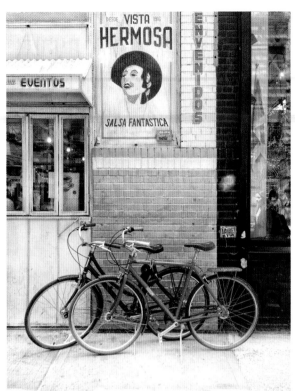

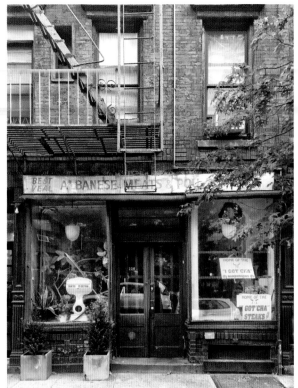

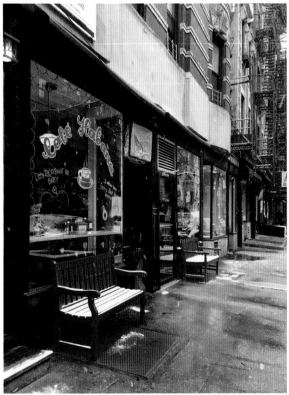

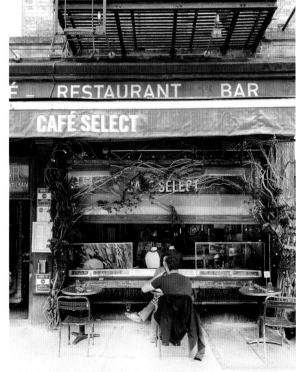

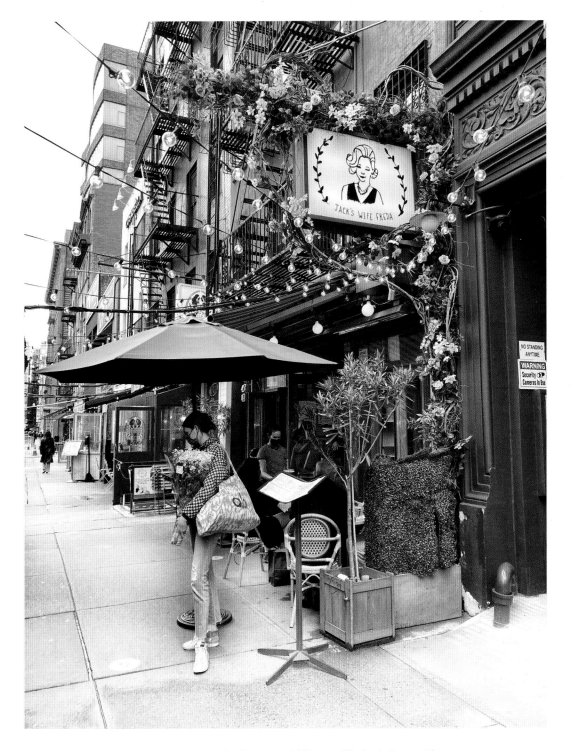

OPPOSITE, CLOCKWISE FROM TOP LEFT: Perfectly propped bikes on Elizabeth Street; Albanese Meats & Poultry on Elizabeth Street, a neighborhood butcher shop since 1923; Swiss restaurant Cafe Select on Lafayette Street; Cuban-Mexican restaurant Café Habana on Prince Street
ABOVE: Waiting for a table at Jack's Wife Freda on Lafayette Street

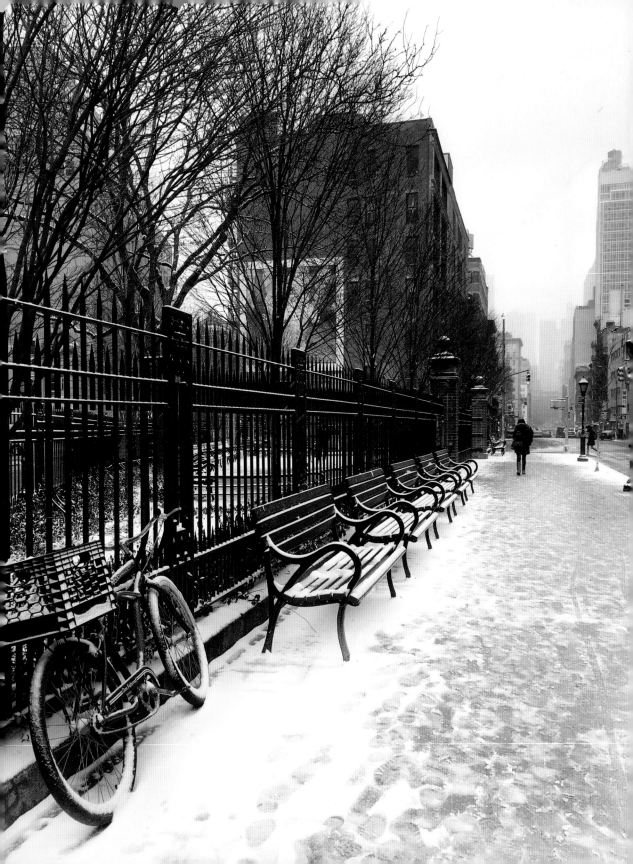

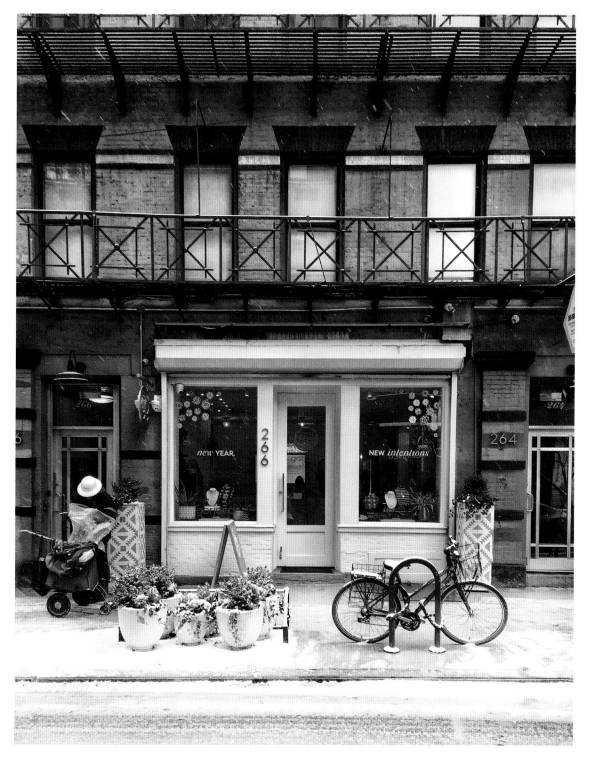

OPPOSITE: Cleveland Place on a moody winter day **ABOVE:** An intrepid mail carrier making a delivery on Elizabeth Street

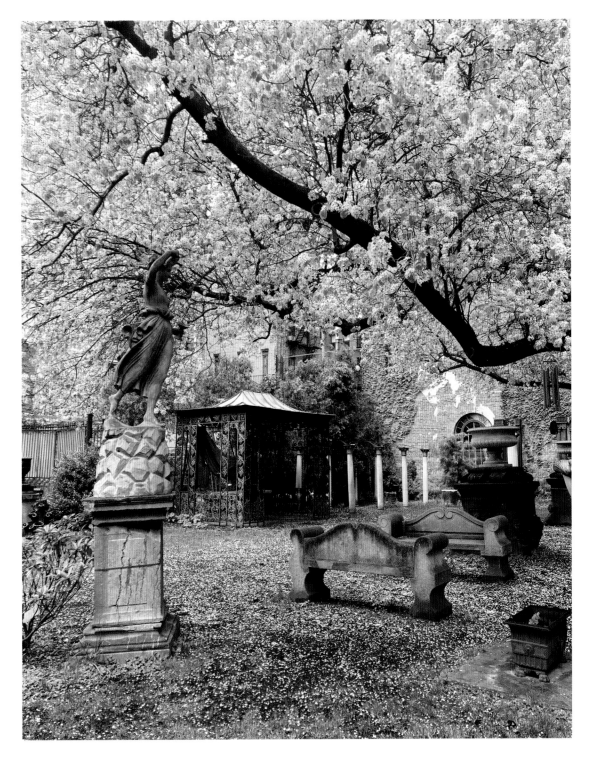

OPPOSITE, CLOCKWISE FROM TOP LEFT: A collection of architectural pieces and sculptures throughout the eclectic Elizabeth Street Garden, an urban oasis between Prince and Spring Streets **ABOVE:** A magnificent tree blooms in the garden.

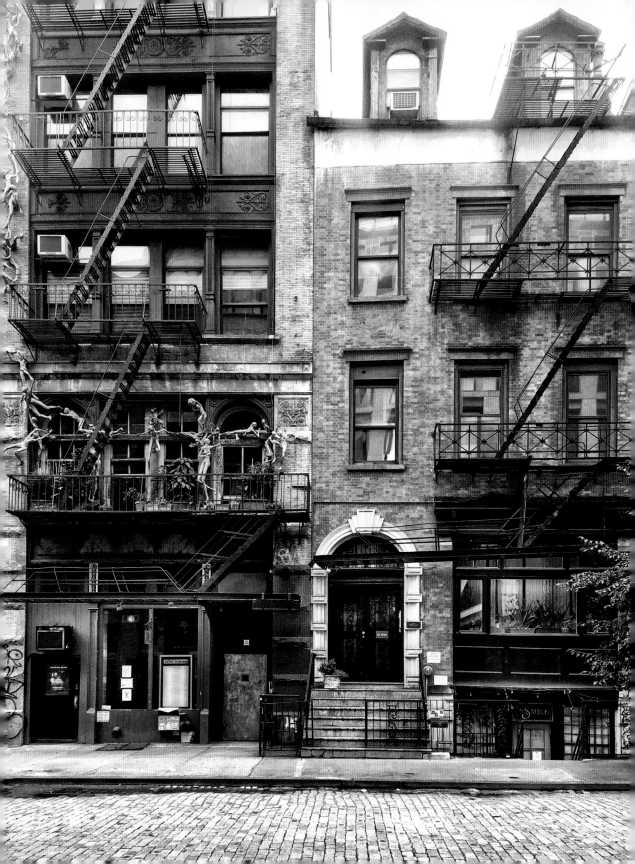

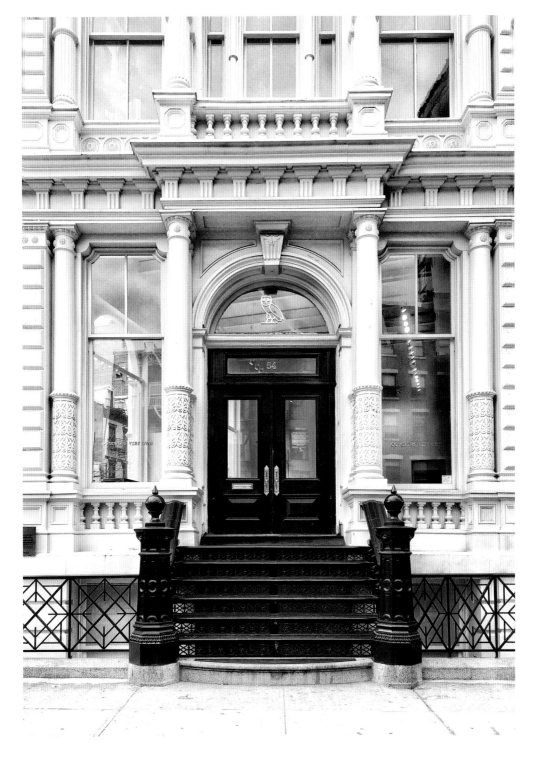

OPPOSITE: Whimsical gold dancing sculptures adorn 24 Bond Street (left); an 1831 brick townhouse and home to the Smile restaurant (right) **ABOVE:** A beautiful and historic cast-iron landmark building (ca. 1874) on Bond Street

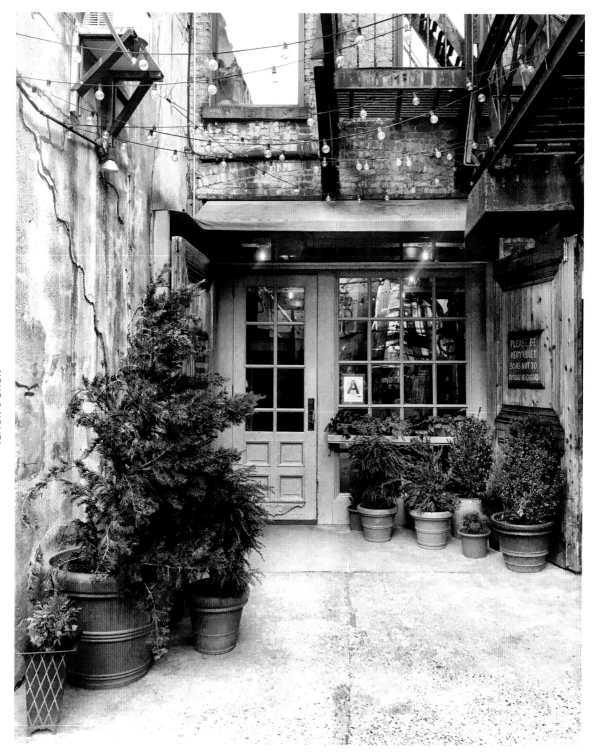

ABOVE: Freemans restaurant in hard-to-find Freemans Alley (a few blocks east of Nolita)

My Favorite Streets

NOHO & NOLITA

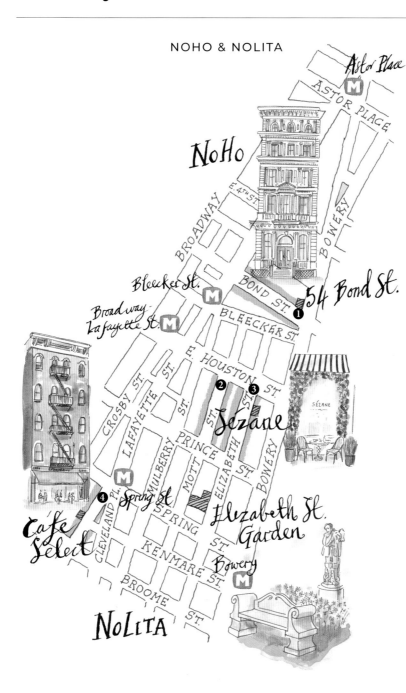

❶ Bond Street
A wonderful mix of old and new architectural gems on a charming cobblestoned street

❷ Mott Street
A quiet block with old-world character between Houston and Prince Streets

❸ Elizabeth Street
The international flavor of the boutiques and restaurants between Houston and Prince Streets has a distinctly European feeling.

❹ Lafayette Street
There's always a lively scene at the cafés and restaurants along the stretch between Spring and Broome Streets.

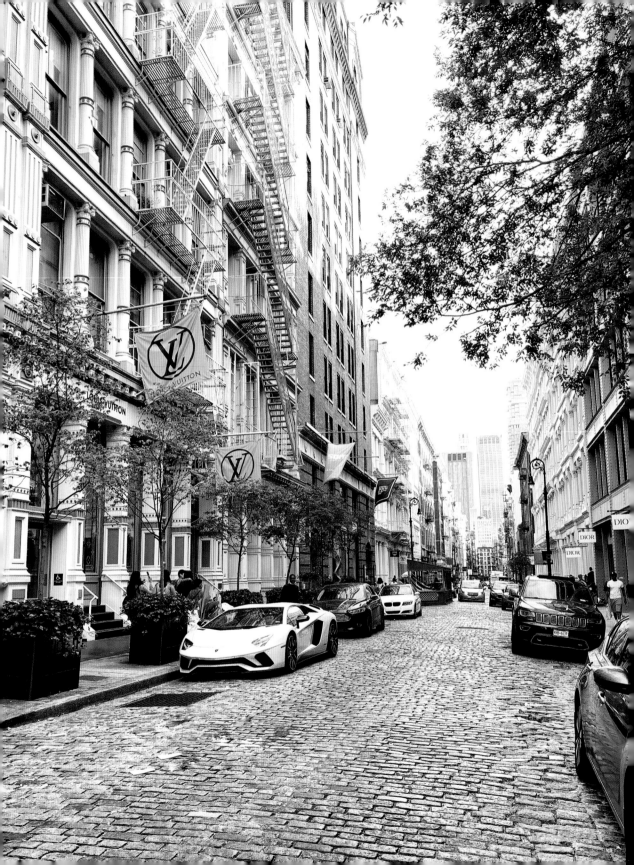

SOHO

S oHo (*South of Houston Street*) is home to the greatest collection of cast-iron architecture in the world. These gorgeous buildings, mostly constructed between 1840 and 1880, came close to being destroyed by the 1960s Lower Manhattan Expressway Project, which would have meant a highway in the middle of SoHo! But thanks to journalist and urban activist Jane Jacobs, preservationists, civic leaders, and resident artists, the neighborhood was saved and those distinctive buildings remain intact. And in 1973, the New York City Landmarks Preservation Commission designated the SoHo–Cast Iron Historic District, protecting about five hundred of these beautiful structures.

My own first experience of SoHo goes back to the late seventies, when I was lucky enough to land an internship at the renowned Leo Castelli Gallery at 420 West Broadway. Back then, SoHo was where struggling artists lived in industrial loft spaces (before most people had even heard of open-concept living), and there were just a handful of restaurants—Kenn's Broome Street Bar, Fanelli Cafe, and Raoul's—tucked among the art galleries, and no shops to speak of. Today's SoHo looks a whole lot different. While there are a few galleries still around, they are greatly outnumbered by the high-end designer boutiques, fabulous restaurants (La Mercerie Cafe is my current go-to, but Balthazar is still a longtime favorite), and chic hotels. (And now those formerly funky artists' lofts aren't so funky, or affordable, anymore.) But even with all of these changes, the cobblestoned streets, iconic cast-iron and brick buildings, and—most important—the neighborhood's unique character remain. So, while I can appreciate the neighborhood's party-like atmosphere on most days, my favorite time to experience SoHo's special magic is in the early morning hours, before the throngs of shoppers and revelers have arrived.

Designer shops and fancy cars on cobblestoned Greene Street between Prince and Spring Streets

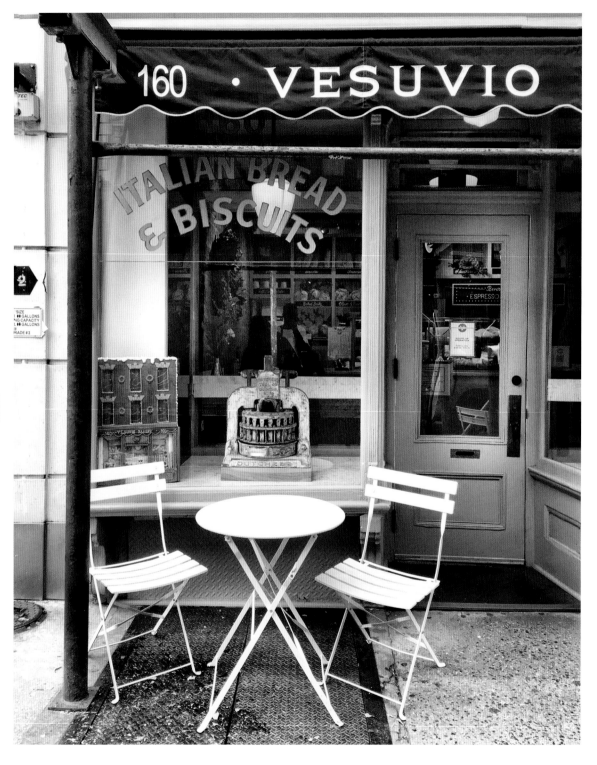

ABOVE: The hundred-year-old Vesuvio Bakery on Prince Street **OPPOSITE:** A dapper gentleman pedals past this striking private home (ca. 1833) on Prince Street.

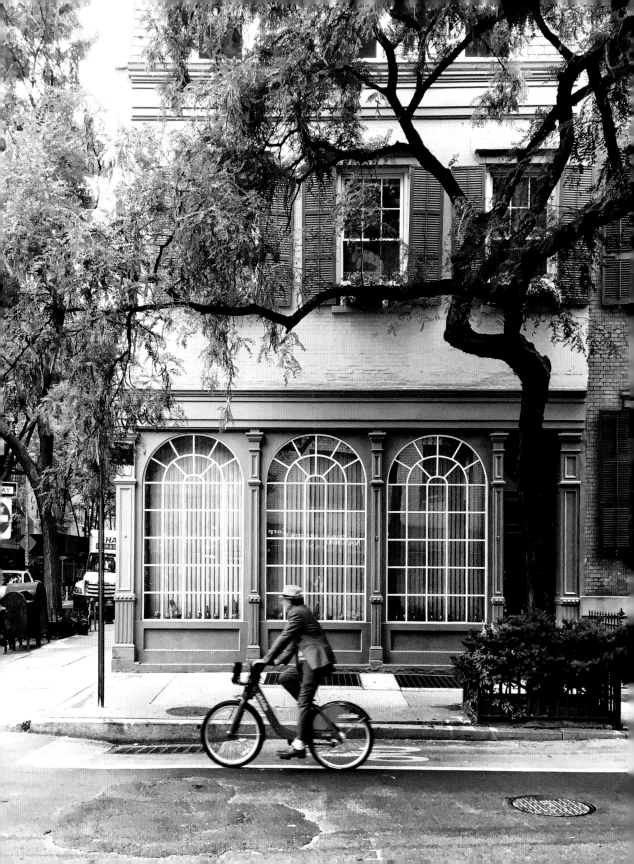

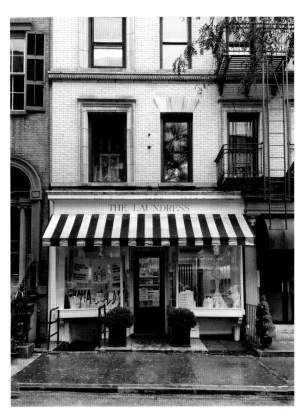

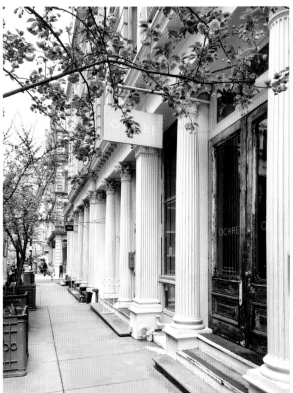

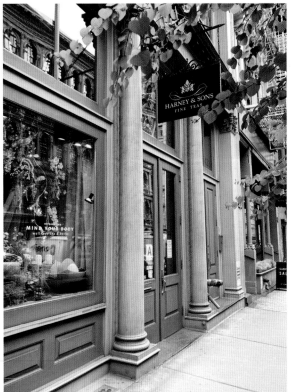

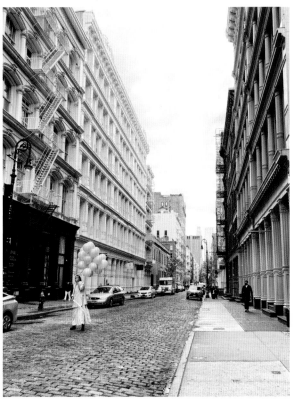

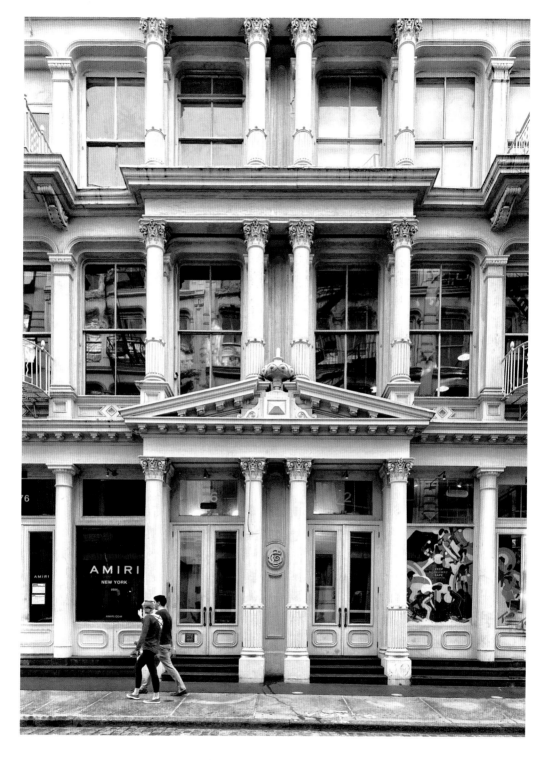

OPPOSITE, CLOCKWISE FROM TOP LEFT: The Laundress on Prince Street; cherry blossoms on Broome Street; pink balloons on Greene Street between Houston and Prince Streets; Harney & Sons Fine Teas on Broome Street **ABOVE:** A cast-iron masterpiece nicknamed "the King of Greene Street"

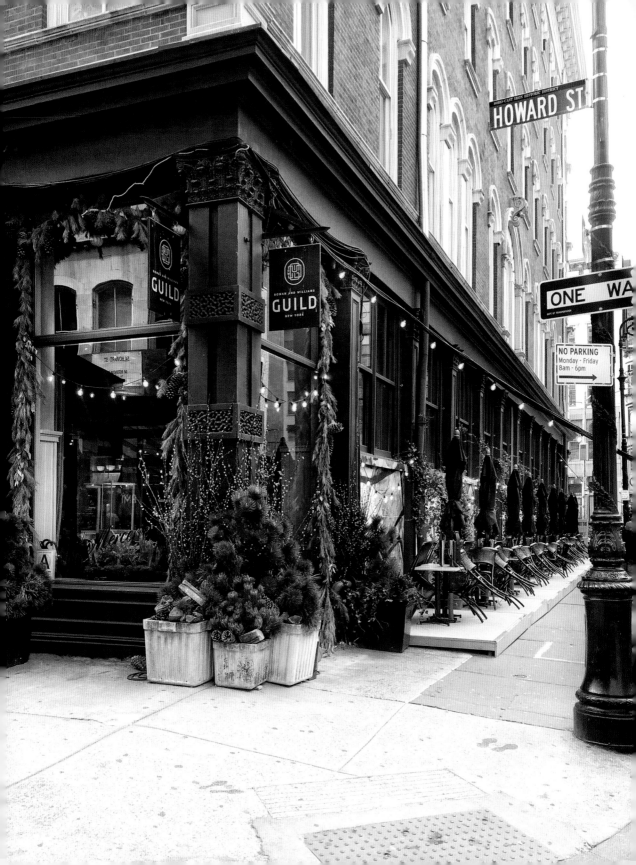

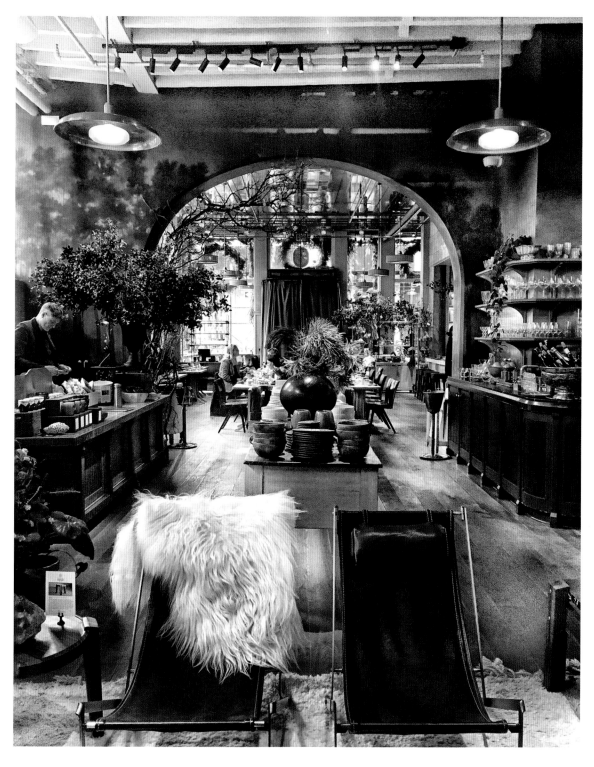

OPPOSITE: La Mercerie Cafe at the Roman and Williams Guild's chic navy exterior on Howard Street
ABOVE: Roman and Williams's stylish interior

ABOVE: Pretty leaf and flower cast-iron detail on Mercer Street
OPPOSITE, CLOCKWISE FROM TOP LEFT: A mix of decorative architectural details throughout the neighborhood

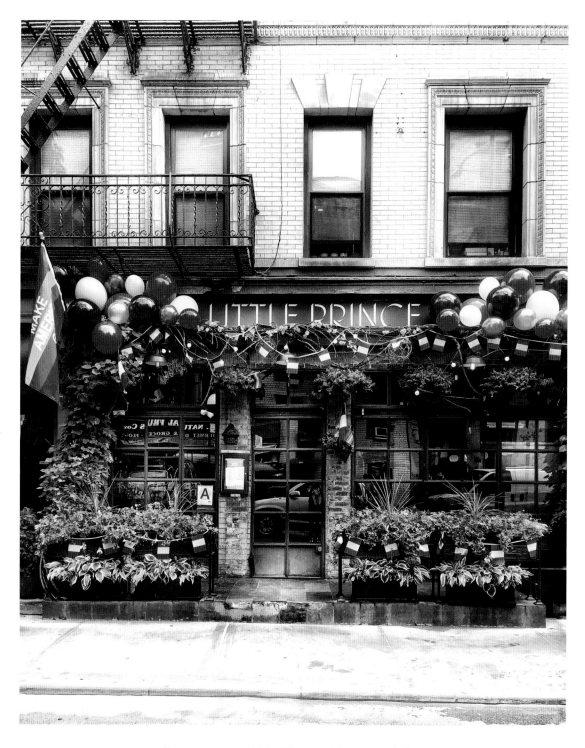

ABOVE: French restaurant Little Prince on Prince Street is festooned with balloons and flags in honor of Bastille Day. **OPPOSITE, CLOCKWISE FROM TOP LEFT:** French clothing store A.P.C. on Mercer Street; outdoor dining at Balthazar on Spring Street; table for two on Thompson Street; Raoul's bistro on Prince Street

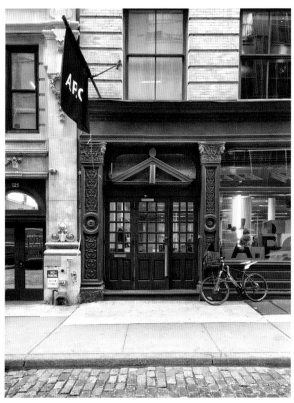
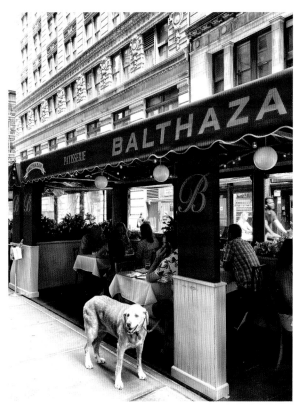
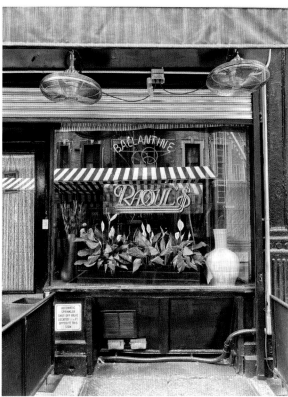
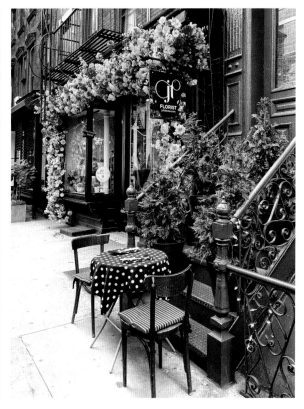

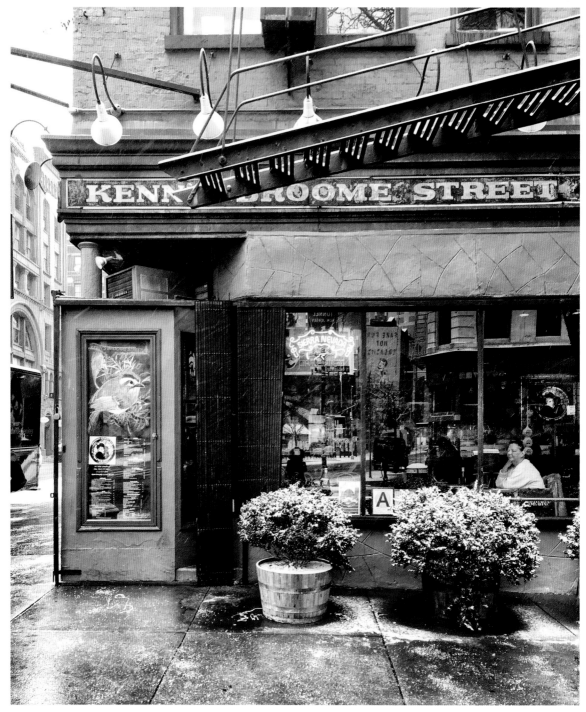

ABOVE: Kenn's Broome Street Bar, a longtime neighborhood favorite on West Broadway
OPPOSITE: A rack of riderless Citibikes sits gathering snow on Mercer Street.

ABOVE: A beautiful paned window showcases an unusual array of plants in a private home on Prince Street. **OPPOSITE:** Felix Roasting Co.'s elegantly decorated interior on Greene Street

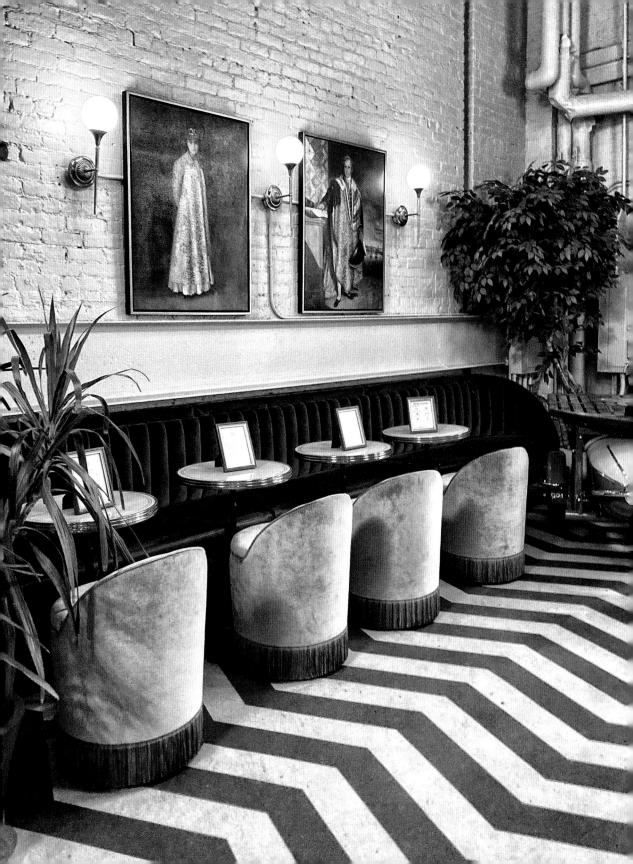

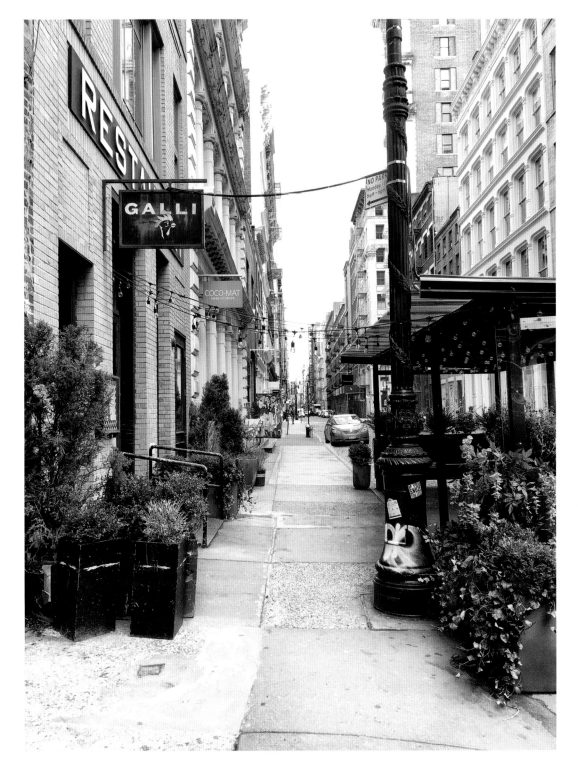

ABOVE: Galli restaurant's flowers and potted plants add a nice touch of greenery to Mercer Street.

My Favorite Streets

SOHO

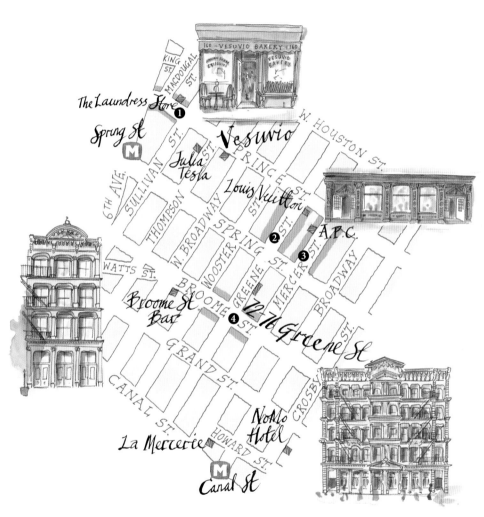

❶ Prince Street
A charming block of historic homes and fabulous restaurants between MacDougal and Sullivan Streets

❷ Greene Street
My favorite cobblestoned stretch between Prince and Spring Streets has two of the most beautiful cast-iron buildings in the neighborhood.

❸ Mercer Street
Another classic cobblestoned street, with wonderful shops and buildings, between Prince and Spring Streets

❹ Broome Street
Some of the most outstanding cast-iron structures are between Mercer and Wooster Streets.

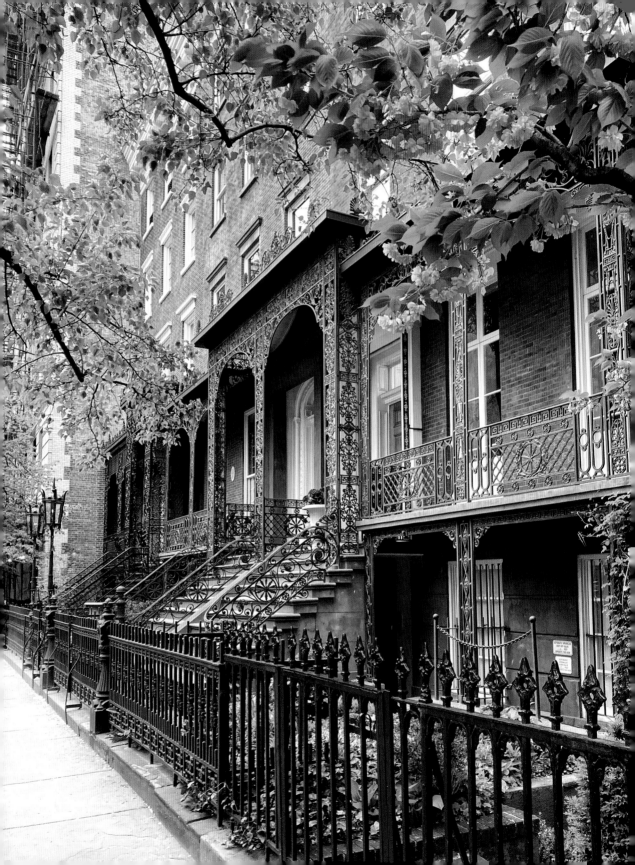

GRAMERCY PARK

One night many years ago, I walked through Gramercy Park during a major snowstorm. Parked cars were completely covered in snow, old-fashioned streetlamps were glowing, and as I passed the ornate cast-iron balconies of Gramercy Park West, I felt as if I'd stepped back in time, like the genteel neighborhood hadn't changed since the mid-1800s. I've been smitten ever since.

Gramercy Park was originally swampland when the park was laid out in 1833. It is one of only two private parks in New York City, and only lucky residents of the immediate area are granted a key. (You can still take in its beauty through the slats of the iron fencing.) Long considered one of New York's most upscale neighborhoods, it was once home to Theodore Roosevelt, John Barrymore, and James Cagney. It also boasts two historic private clubs in landmarked mansions on the south side of the park: the Players Club, founded in 1888 by actor Edwin Booth (brother of John Wilkes Booth) in a Stanford White–designed building; and the National Arts Club, inside former New York governor Samuel Tilden's Victorian Gothic house.

My favorite approach to the park is to walk north along Irving Place (named after Washington Irving). It's a short stretch but filled with wonderful restaurants: Friend of a Farmer on the west side; historic Pete's Tavern, billed as "New York's Oldest Original Bar" (open since 1864), on the east. And I never miss the chance to stroll 19th Street between Irving Place and 3rd Avenue, dubbed "block beautiful," where you'll find the most unusual Dutch-inspired carriage house. After a stroll around the park, I like to head to historic Stuyvesant Square, an under-the-radar gem only a few blocks east of Gramercy Park. The square comprises Rutherford Place, a quiet block of lovely townhouses; the beautiful Stuyvesant Park; and the historic Friends Seminary and Meetinghouse. It's worth the walk.

Ornate cast-iron verandas and cherry blossoms on beautiful
Gramercy Park West

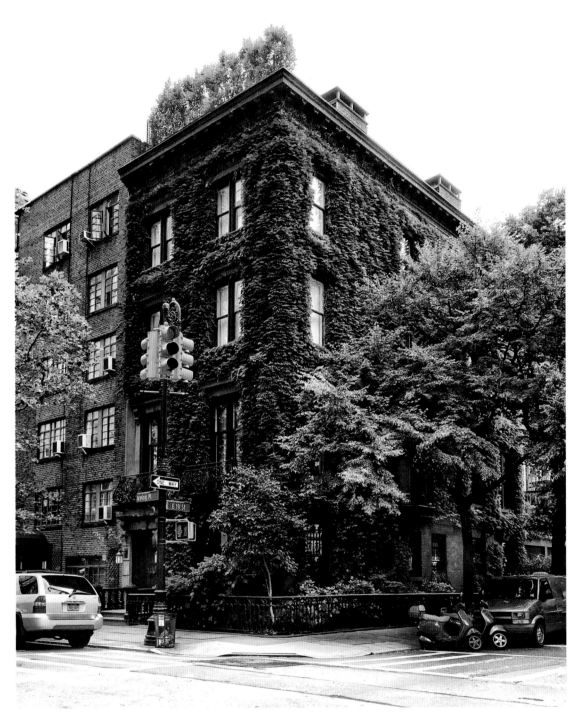

ABOVE: A handsome ivy-covered 1854 mansion on the corner of Irving Place and East 19th Street
OPPOSITE, CLOCKWISE FROM TOP LEFT: Historic Pete's Tavern on the corner of East 18th Street and Irving Place; old-fashioned lampposts on Gramercy Park East; lacy cast-iron balconies on Irving Place; a French Gothic apartment building on Gramercy Park East

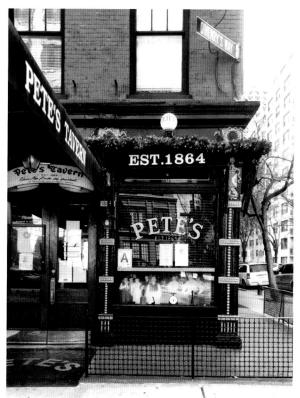

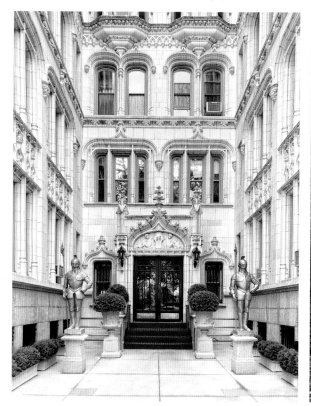
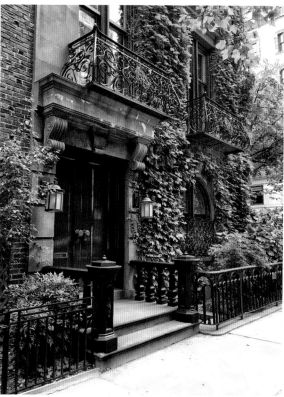

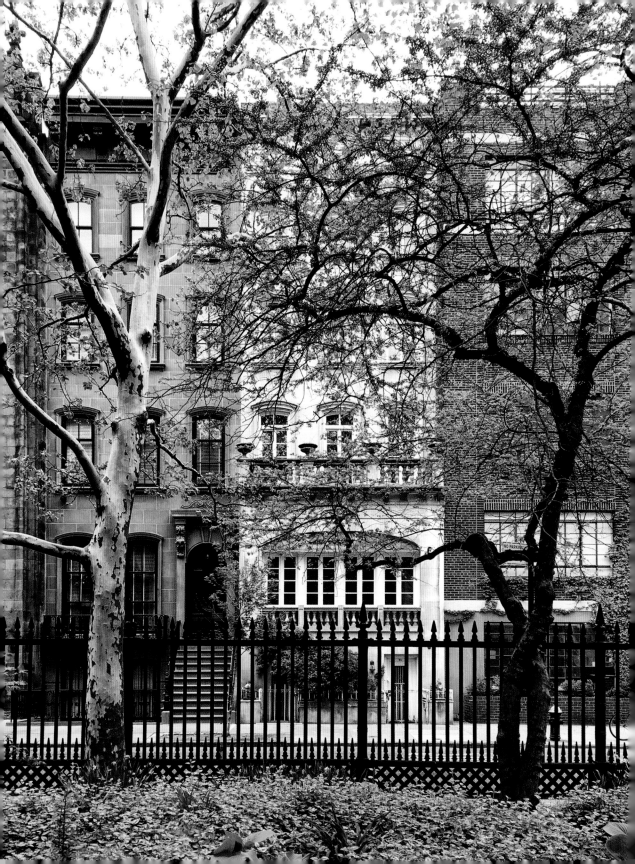

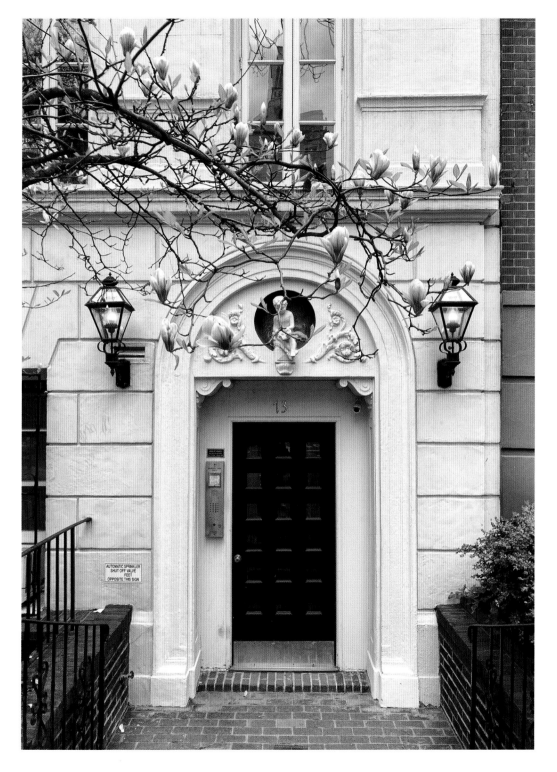

OPPOSITE: Looking out from Stuyvesant Square Park onto scenic Rutherford Place
ABOVE: A romantic entrance to a Gramercy Park South building

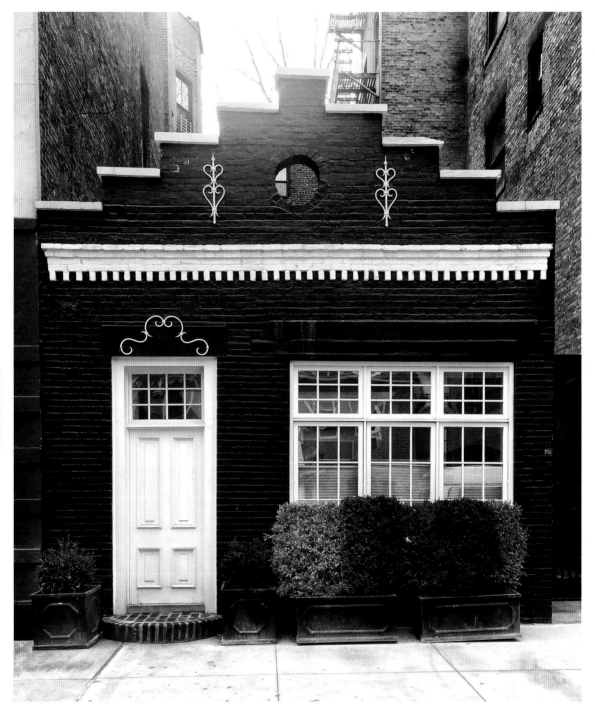

ABOVE: A unique one-story Dutch-inspired carriage house on East 19th Street **OPPOSITE:** A stunning 1861 carriage house on East 19th Street, New York's "block beautiful"

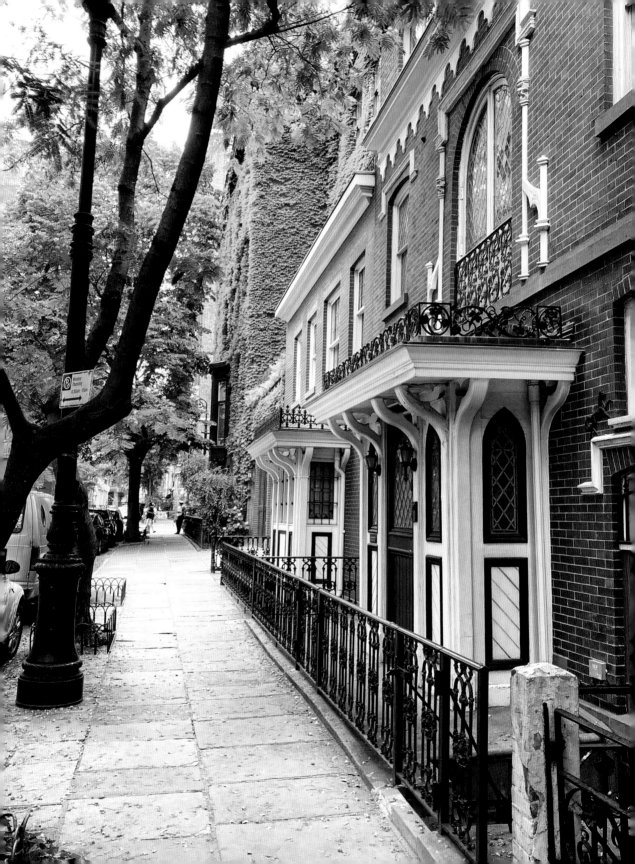

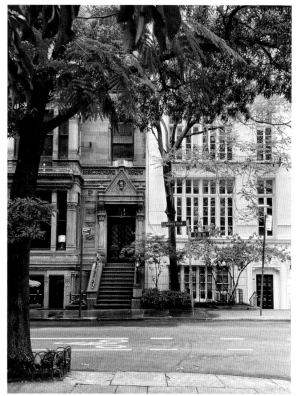
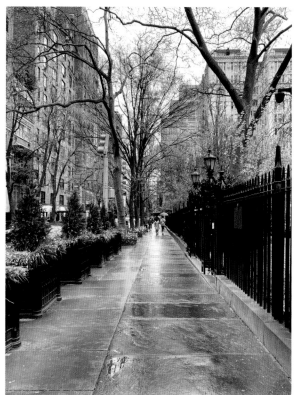
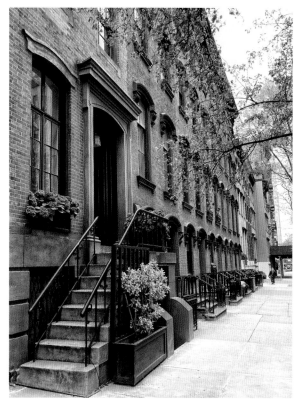
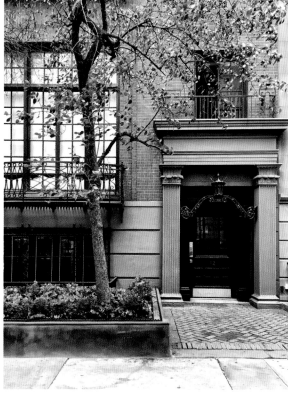

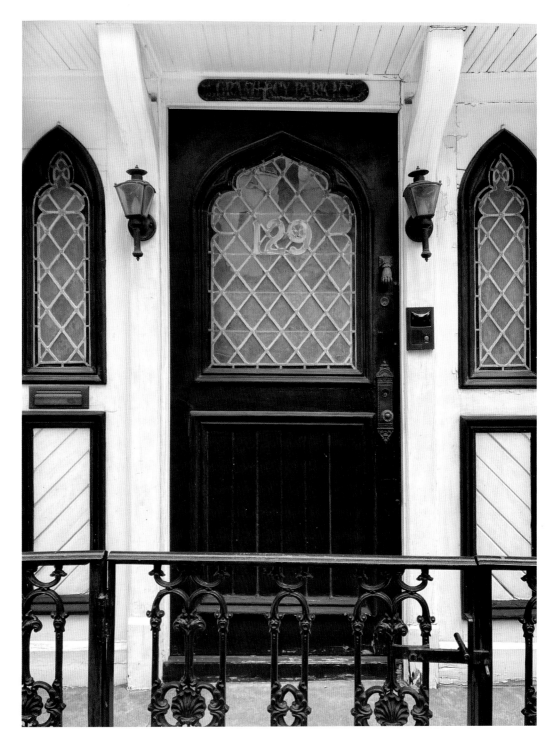

OPPOSITE, CLOCKWISE FROM TOP LEFT: The National Arts Club (on the left); Gramercy Park North on a rainy April day; a refined entrance on Gramercy Park North; a lovely row of townhouses on East 18th Street between Irving Place and 3rd Avenue **ABOVE:** Graphic black-and-white door details on East 19th Street

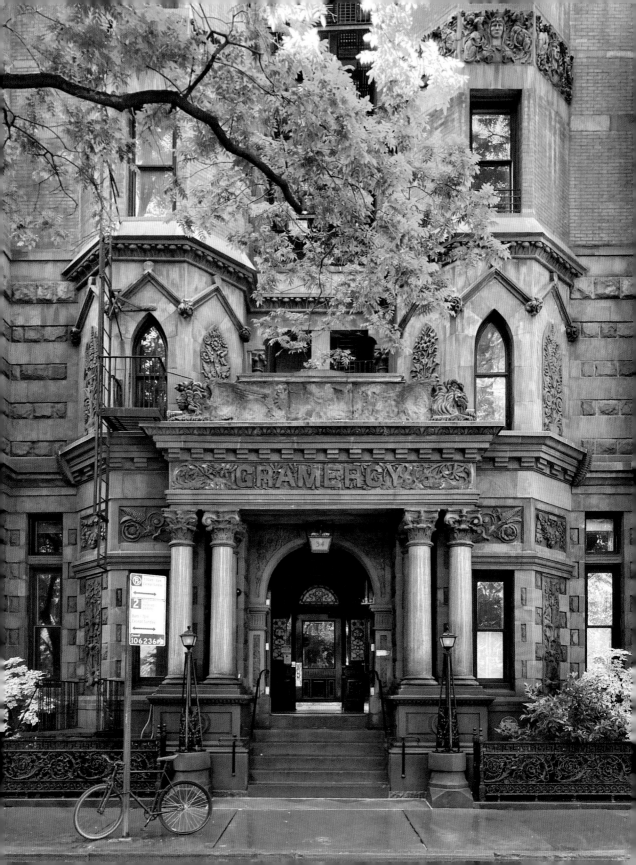

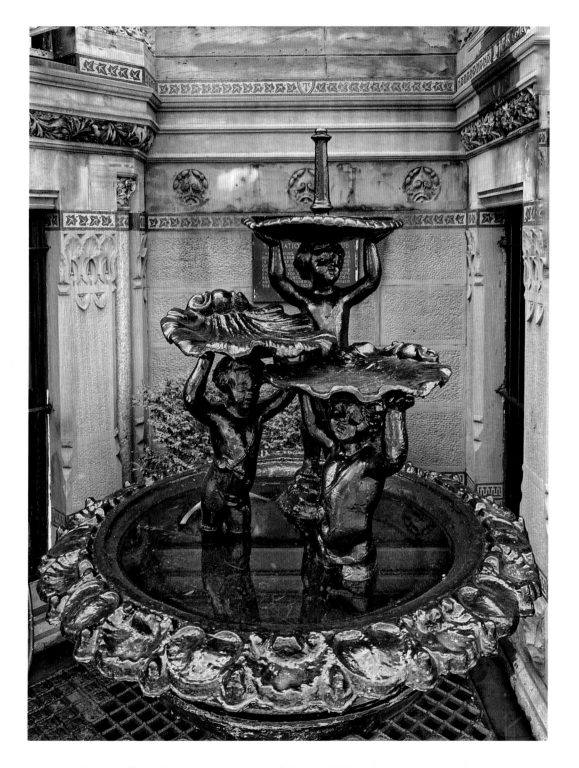

OPPOSITE: The magnificent Gramercy apartment building (ca. 1883) on Gramercy Park East was one of New York City's first co-ops. **ABOVE:** The National Arts Club's whimsical cherub fountain on Gramercy Park South

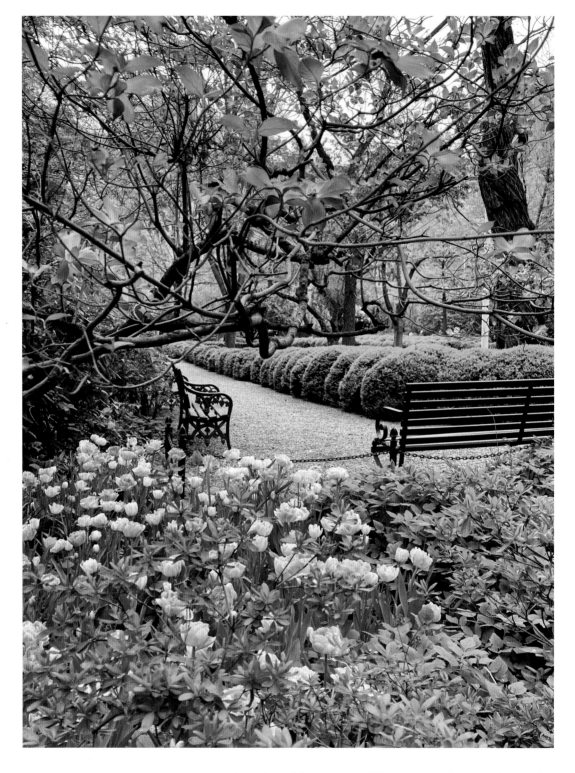

ABOVE: A sneak peek into a corner of Gramercy Park's enchanting garden, featuring tulips, boxwoods, and flowering trees

My Favorite Streets

GRAMERCY PARK

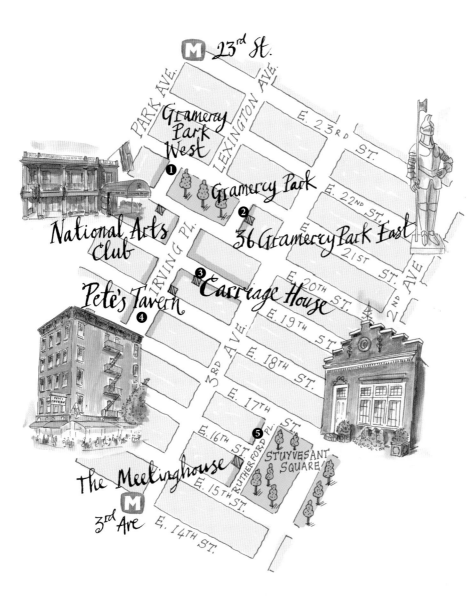

❶ Gramercy Park West
A row of historic homes with exquisite cast-iron balconies overlooking the park

❷ Gramercy Park East
You'll find a one-of-a-kind Gothic building (with knights in shining armor at the entrance) and a magnificent 1883 apartment building.

❸ E. 19th Street
New York's "block beautiful," between Irving Place and 3rd Avenue, is filled with unique homes.

❹ Irving Place
The four-block walk from 16th Street up to the park is packed with great restaurants and beautiful buildings.

❺ Rutherford Place
The beautiful mid-nineteenth-century homes and St. George's Church overlooking Stuyvesant Square Park are a secret gem.

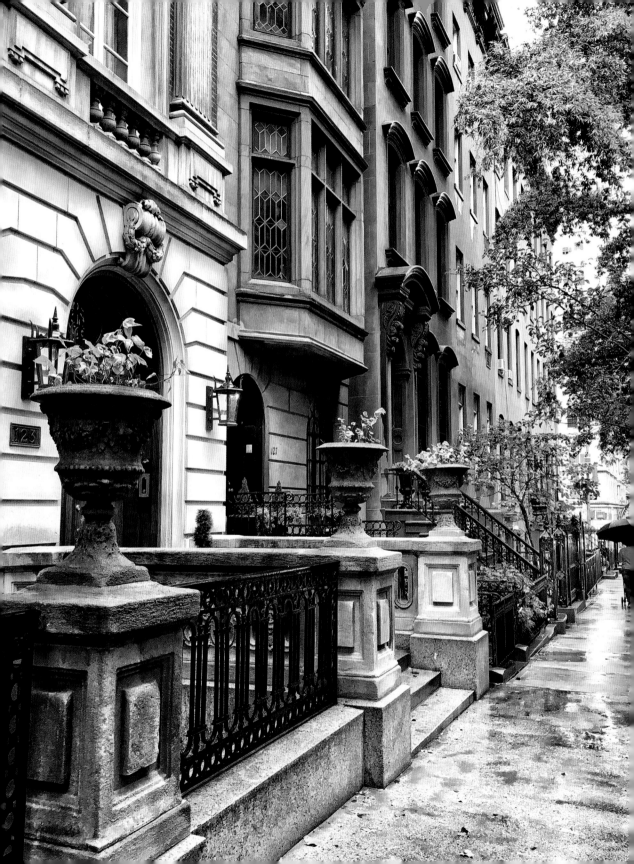

MURRAY HILL

M urray Hill, an often-overlooked Midtown jewel, was once considered one of the city's poshest addresses. In the late nineteenth century, residents included the Vanderbilts, Astors, and Rockefellers. The outstanding Morgan Library & Museum on 37th Street and Madison Avenue is perhaps the neighborhood's most famous landmark, but if you walk just a few blocks east, you'll discover Gilded Age townhouses designed by architects Stanford White and McKim, Mead & White; delightful row houses; and Sniffen Court, a hidden, pretty-as-a-picture mews on 36th Street. Only a few blocks north and west are two of my favorite spots in Manhattan: Bryant Park and the New York Public Library.

I first became acquainted with Murray Hill the summer I started working as an editorial assistant at a popular fashion magazine. Two friends visiting from Italy and I spent one month living together in a studio rental on 37th Street and Lexington Avenue. Every day I would walk the eight blocks to my new office on Madison Avenue, but I never actually explored the neighborhood around me. My loss.

Years later, as a full-fledged fashion editor, I was reacquainted with the area when a new-and-improved Bryant Park (it was reopened to critical acclaim in 1992) was chosen as New York Fashion Week's main show space, and I found myself frequenting the park on a regular basis. The Bryant Park Grill became a favorite lunch spot, and the park itself became the perfect oasis for many of us who worked in Midtown. And even though I no longer work nearby, I still make a point of visiting the park anytime I can. With its sweeping green lawn, bistro chairs and tables, and decidedly Parisian vibe—like a mini Luxembourg Gardens in the middle of Manhattan, it's the perfect place to relax after a stroll through Murray Hill.

Stately early-twentieth-century townhouses along East 35th Street between Park and Lexington Avenues

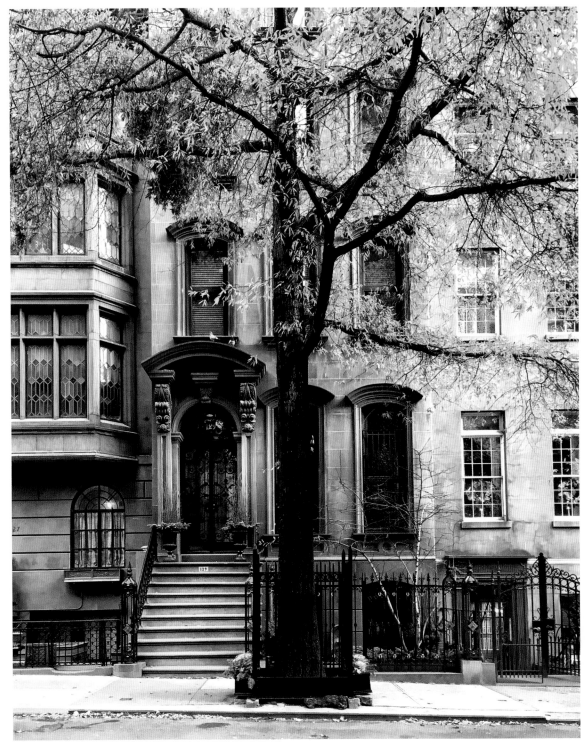

ABOVE: Vivid golden leaves frame an elegant townhouse and bay window on East 35th Street.
OPPOSITE: An ornate iron door and a few charming accessories make a statement on East 35th Street.

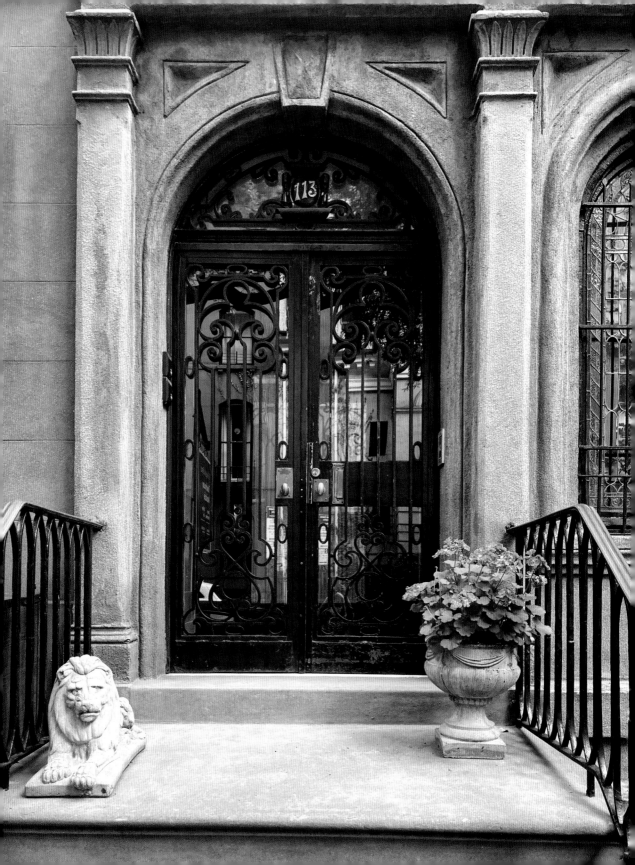

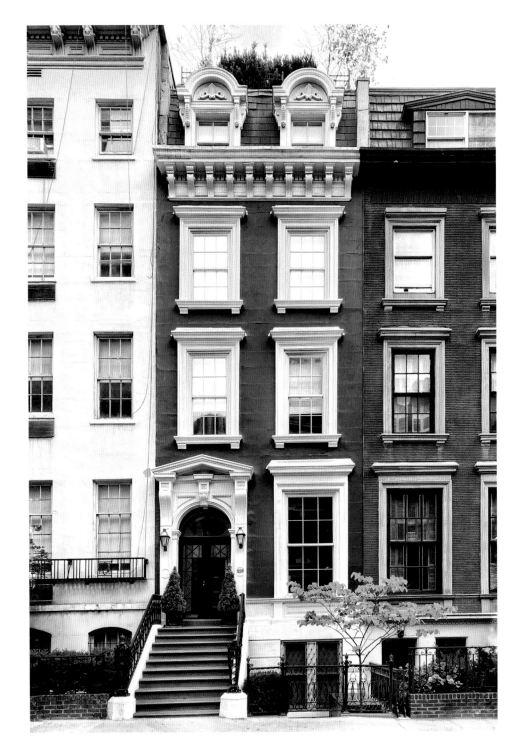

ABOVE: A graceful five-story townhouse with a striking green facade on East 38th Street
OPPOSITE, CLOCKWISE FROM TOP LEFT: Four distinctive entryways include a fanciful gate on East 37th Street, handsome black double doors on East 35th Street, classic arches and urns on East 35th Street, and a gold-trimmed door on East 38th Street.

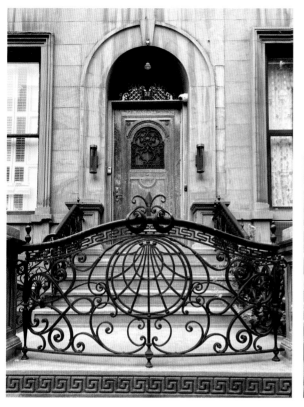
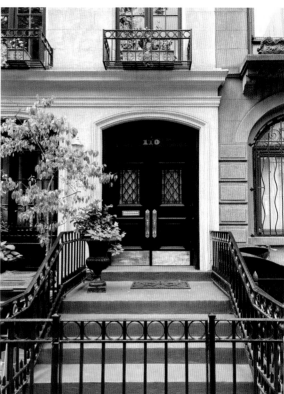
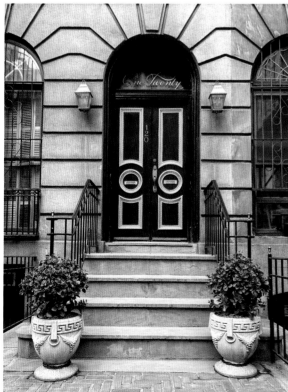
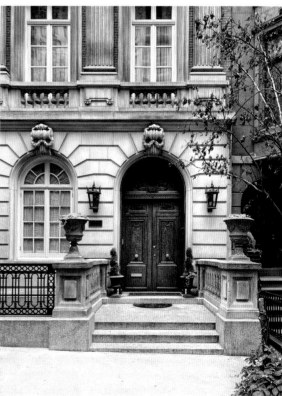

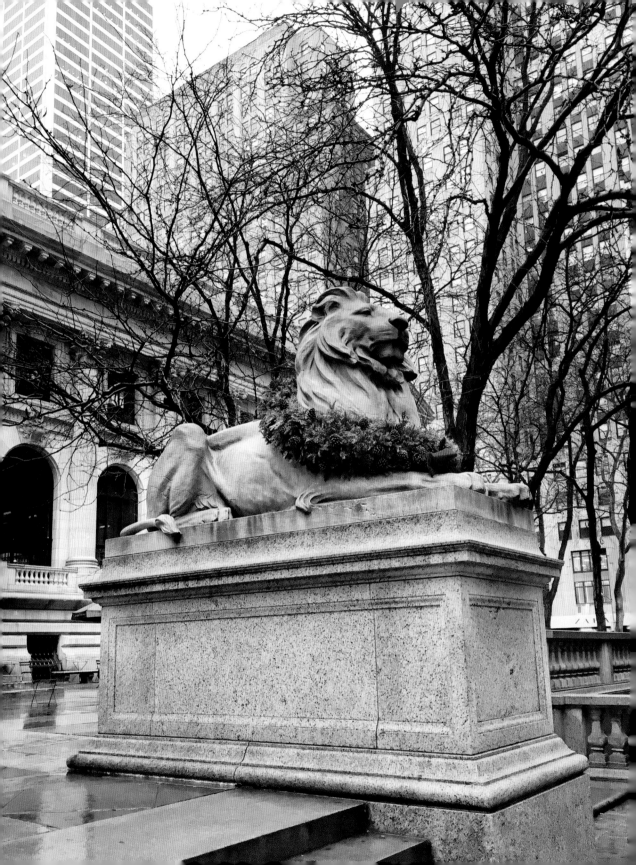

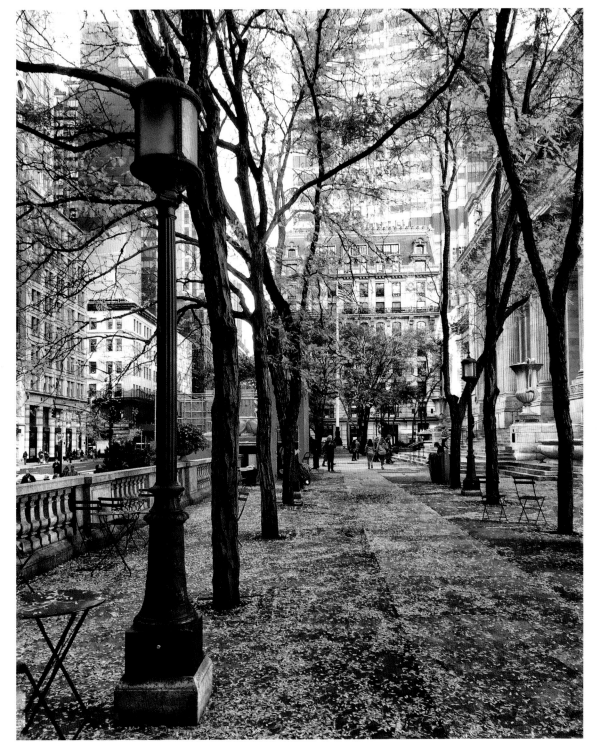

OPPOSITE: "Fortitude," one of the New York Public Library's lion mascots, wears his holiday wreath with pride.
ABOVE: A magical carpet of fall leaves leads the way to the NYPL's main entrance.

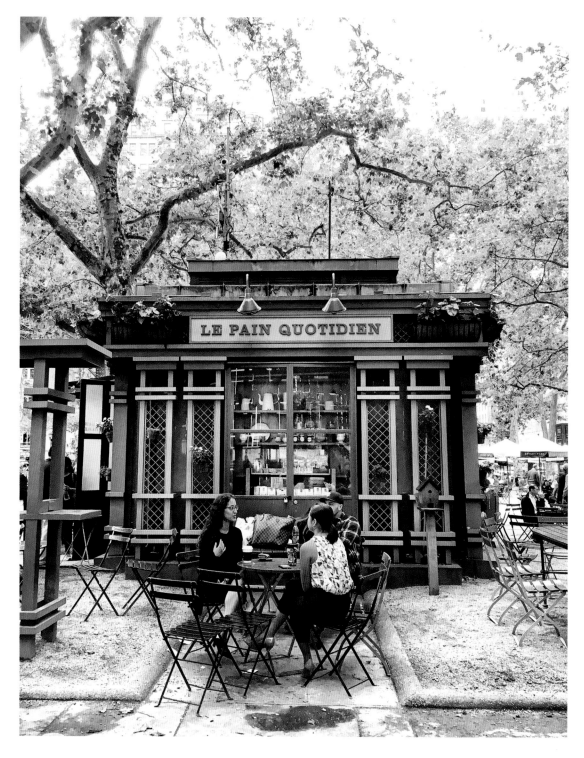

ABOVE: Enjoying a break from the Midtown hustle and bustle at Le Pain Quotidien in Bryant Park
OPPOSITE, CLOCKWISE FROM TOP LEFT: Scenes from Bryant Park: a decorative urn, pretty spring flowers, an enchanting carousel, and the classic Bryant Park Grill

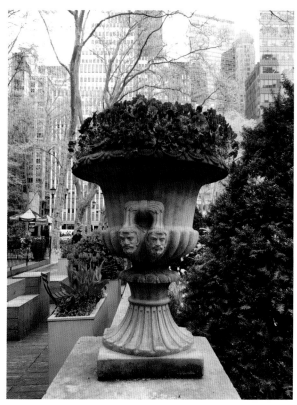
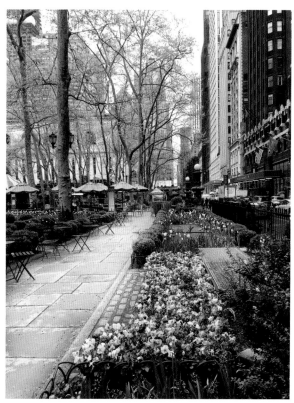
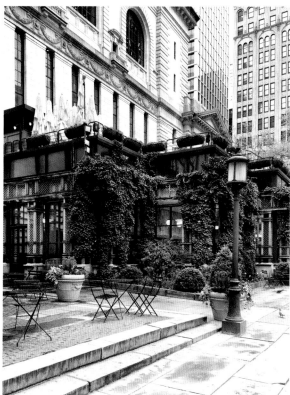
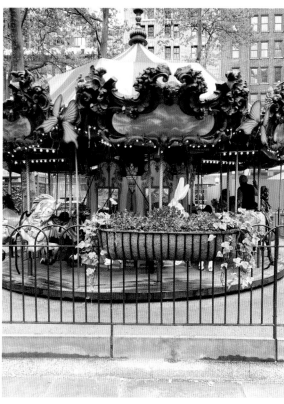

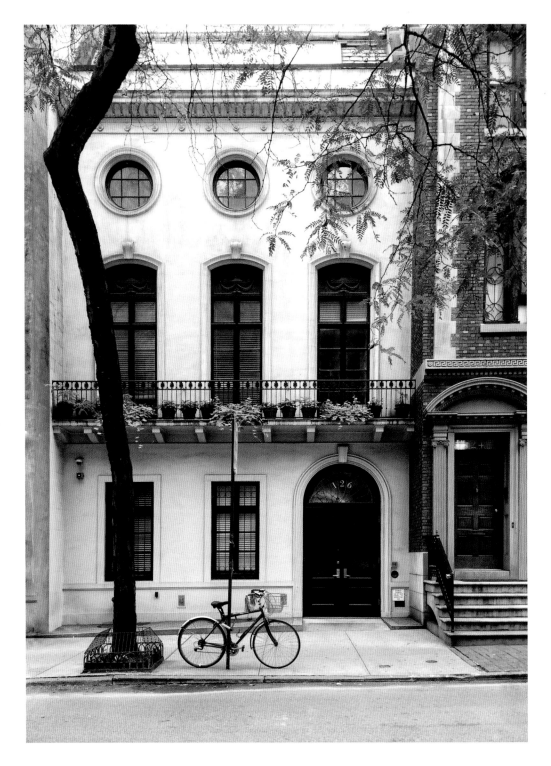

ABOVE: The prestigious Gilded Age architects Delano & Aldrich transformed this former carriage house on 38th Street into their firm's striking headquarters in 1916. **OPPOSITE:** A classic courtyard and dense foliage obscure a brick townhome (ca. 1858) on East 38th Street

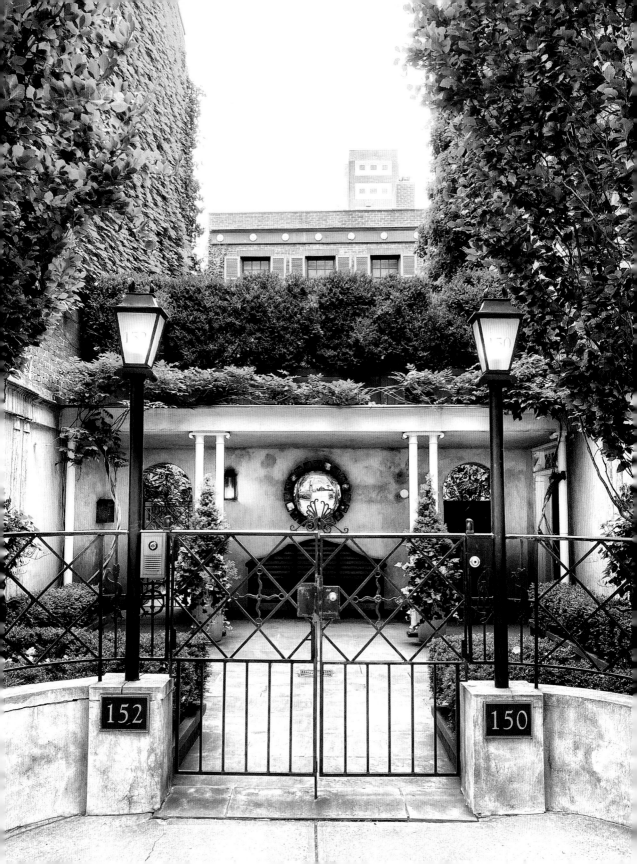

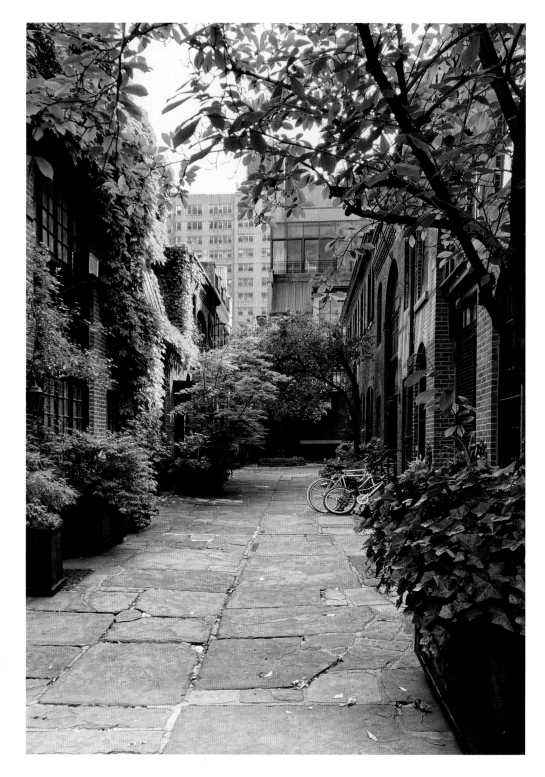

ABOVE: Sniffen Court on East 36th Street is one of the most charming (and private) hidden mews in the city.

My Favorite Streets

MURRAY HILL

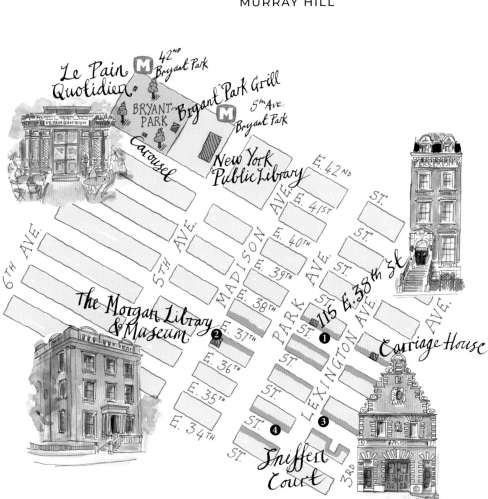

❶ E. 38th Street
Two not-to-be-missed blocks of architectural beauties between Park and 3rd Avenues

❷ E. 37th Street
The Morgan Library & Museum's classic Italianate mansion is on Madison Avenue. You'll find more striking townhouses and doorways between Madison and Lexington Avenues.

❸ E. 36th Street
I always make a special trip to see Sniffen Court, a charming private mews with ten brick stables between Lexington and 3rd Avenues.

❹ E. 35th Street
A beautiful French Renaissance mansion and handsome brownstones between Park and Lexington Avenues

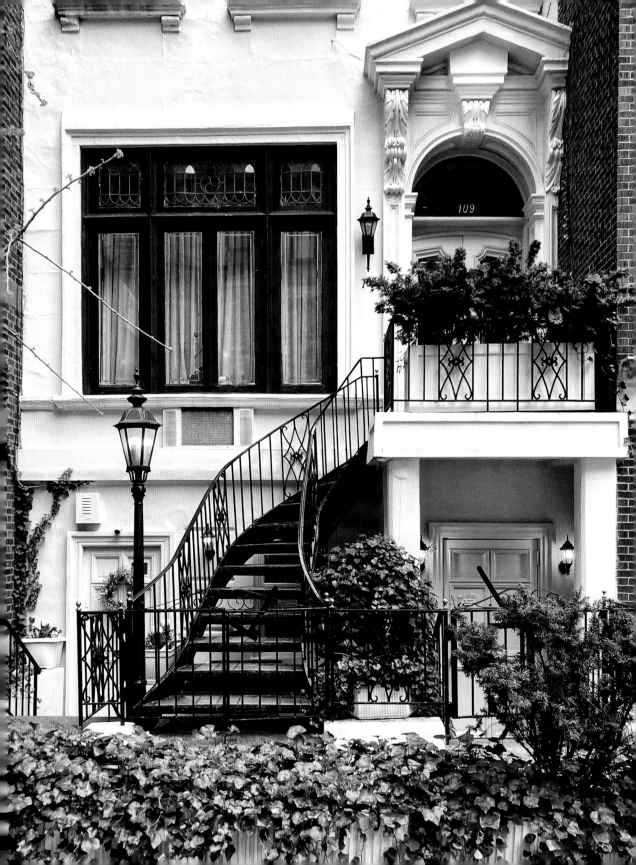

UPPER EAST SIDE

The Upper East Side is practically synonymous with high-end Madison Avenue boutiques, gorgeous limestone mansions, world-class museums, elite private schools (thanks to Gossip Girl), the Plaza Hotel, and Park Avenue "ladies who lunch." And yes, it is all of those things: classic, sophisticated, elegant, and a little more conservative than the rest of Manhattan. (No graffiti here!) Heading uptown always makes me want to get a little more dressed up. But the UES, as it is sometimes known, is also a surprisingly vast area to navigate, stretching from 5th Avenue all the way to the East River, and can feel a bit overwhelming.

My first apartment in New York City was a fifth-floor walk-up on 79th Street and 3rd Avenue. (The rent was affordable by New York City standards.) After two years of living in the neighborhood I made the move downtown but continued to spend a considerable amount of time here—from work meetings to museum outings (I can never get enough of the Frick Museum!) and visits to grandparents and friends. I was even married at the Lotos Club, a French Renaissance mansion on East 66th Street. Even so, I am still discovering nooks and crannies that I've never seen before. After visiting the new Maman café on 3rd Avenue and 81st Street, for example, I turned the corner and discovered the most beautiful row of townhouses with window boxes overflowing with flowers. On my way to meeting friends for lunch, I noticed the graceful white townhouse at 109 East 61st. And leaving the Metropolitan Museum a few years ago, I took a new route to the subway and stumbled upon what is now one of my favorite townhouses in the city (121 East 78th Street). I make a point of shooting it in every season. The Upper East Side will constantly surprise you with its treasures—as long as you're willing to walk A LOT!

An elegant white townhouse with a graceful staircase on East 61st Street

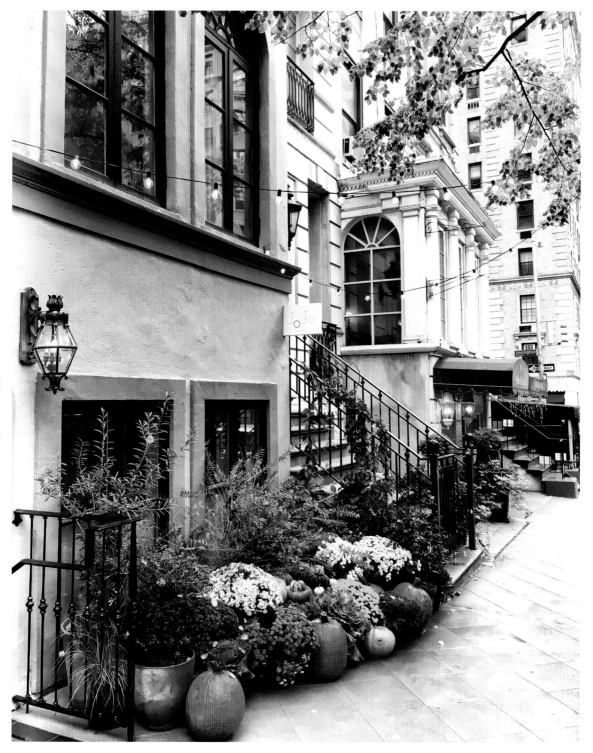

ABOVE: JoJo restaurant's colorful sidewalk display on East 64th Street **OPPOSITE:** A solitary walk in Central Park on a rainy autumn day

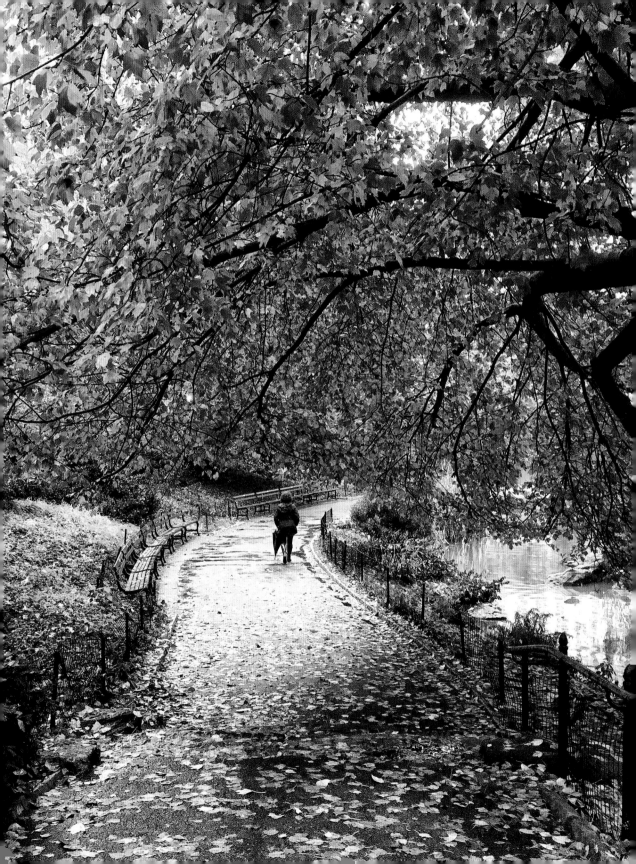

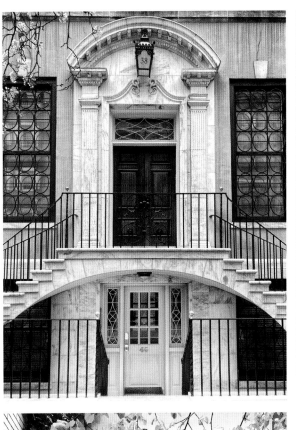
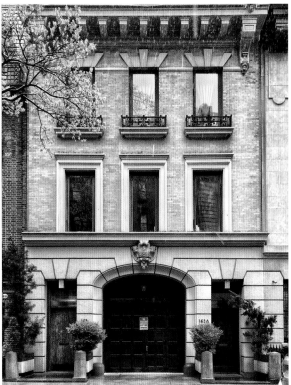
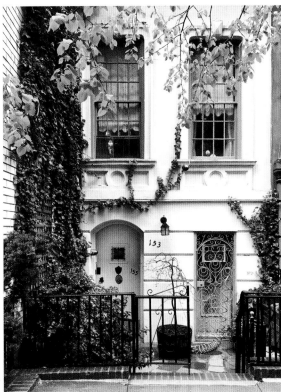
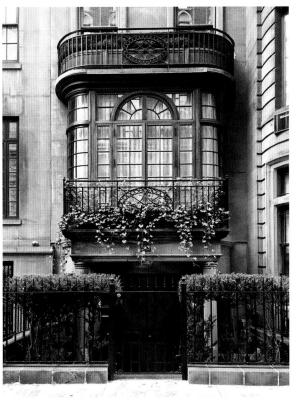

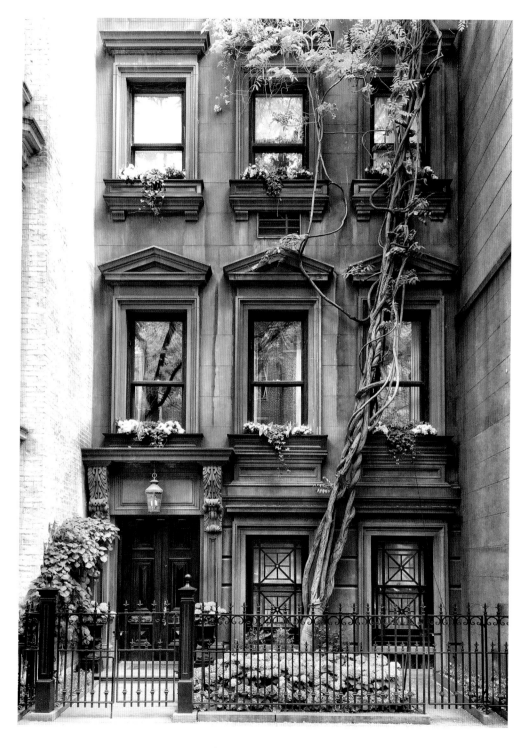

OPPOSITE, CLOCKWISE FROM TOP LEFT: A dramatic staircase on East 69th Street; a handsome townhouse with a private garage on East 70th Street; a striking bay window on East 65th Street; a charming townhome on East 71st Street **ABOVE:** Blue hydrangeas and a dramatic wisteria vine add to the beauty of this classic townhouse on East 78th Street between Park and Lexington Avenues

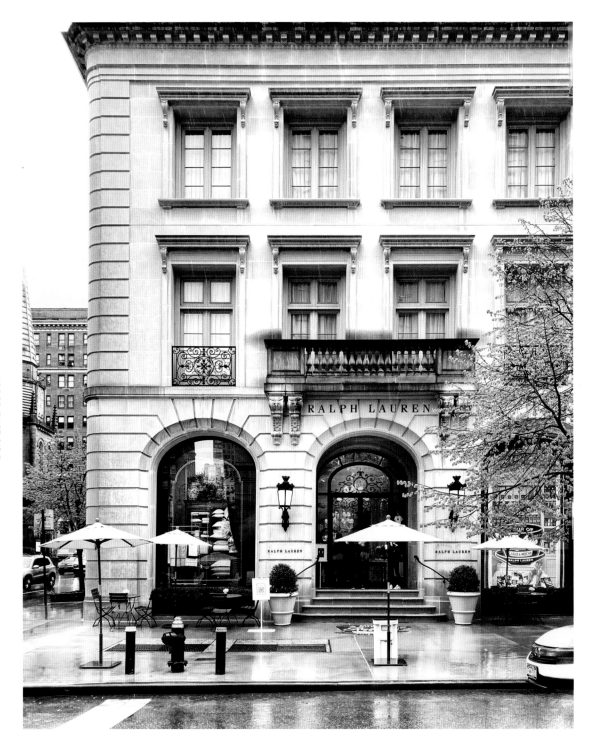

ABOVE: Ralph Lauren's women's flagship store and coffee shop is in a beautiful Beaux Arts–style mansion on the corner of Madison Avenue and East 72nd Street **OPPOSITE, CLOCKWISE FROM TOP LEFT:** The Mark Hotel's flower cart, East 77th Street; Eli's Market, East 80th Street and 3rd Avenue; the Goyard shop, East 63rd Street; Via Quadronno, East 73rd Street

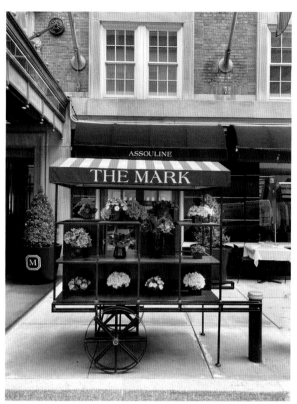

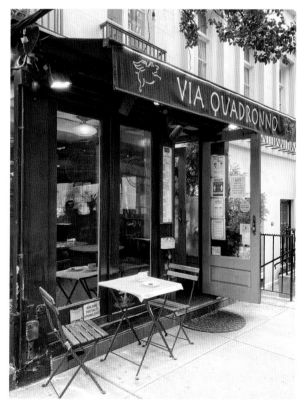

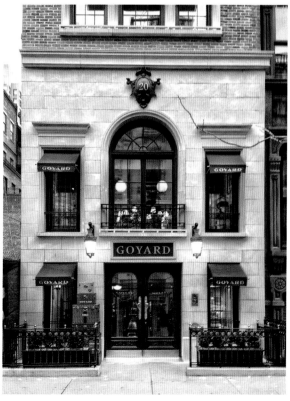

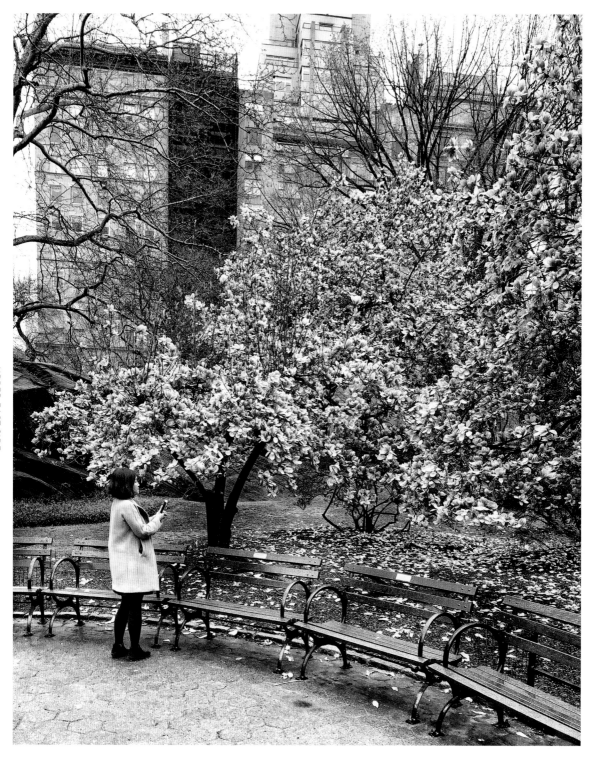

ABOVE: A stunning magnolia tree blooming in Central Park **OPPOSITE:** A pretty row of townhouses on East 80th Street between Lexington and 3rd Avenues

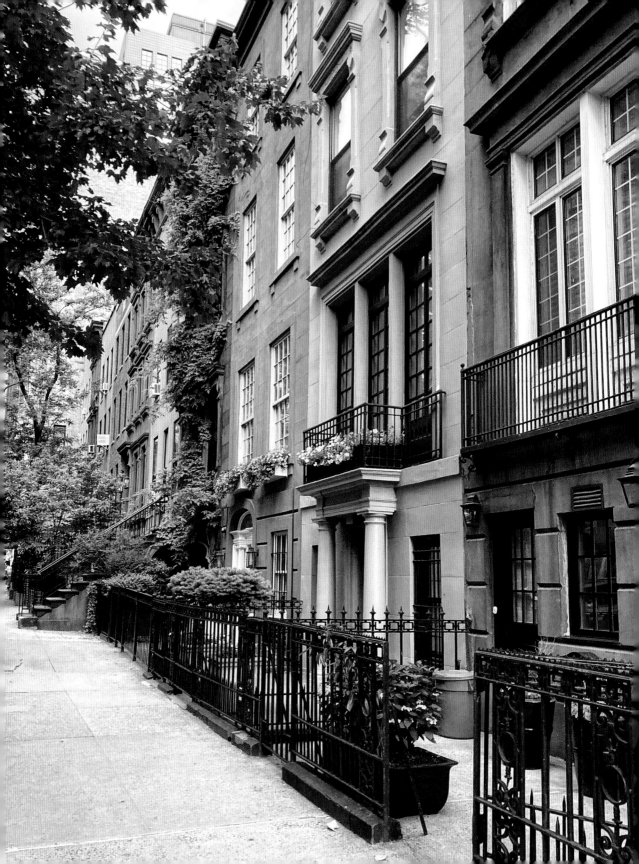

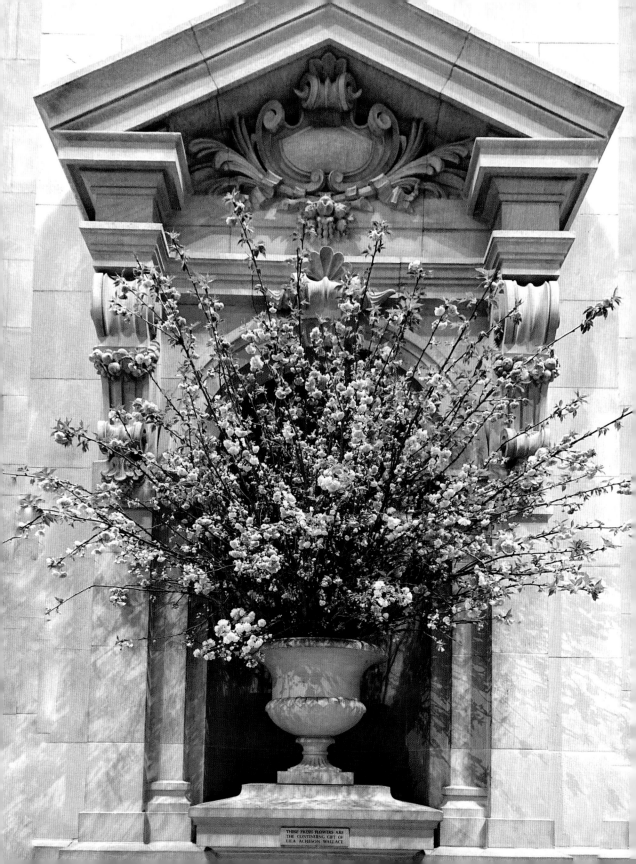

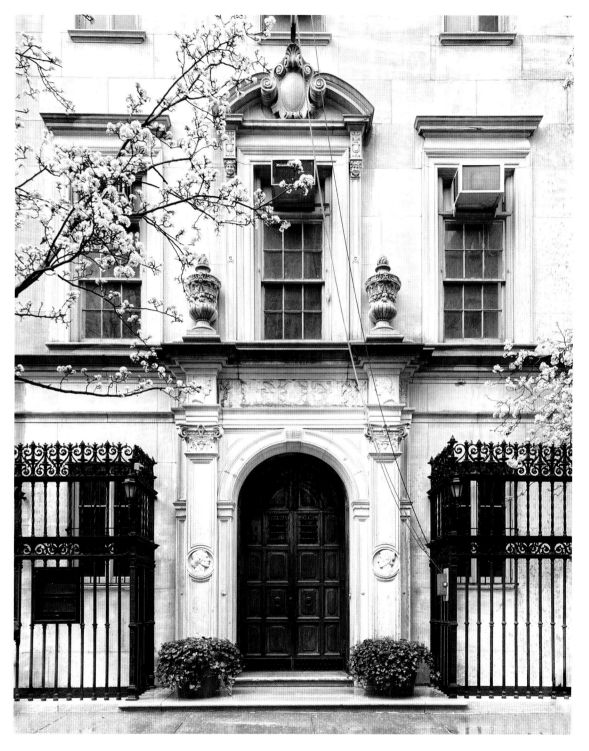

OPPOSITE: A lovely display of cherry blossom branches enhances the Metropolitan Museum of Art's main lobby. **ABOVE:** The Academy Mansion, a stunning neo-Italian Renaissance palazzo (ca. 1916) on East 63rd Street

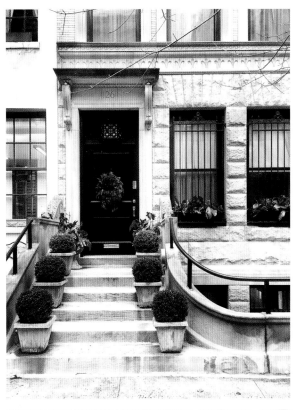
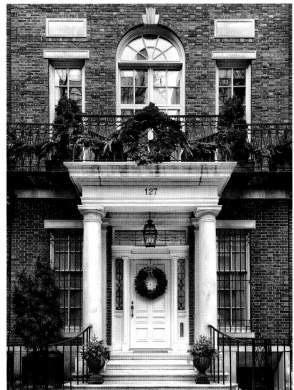
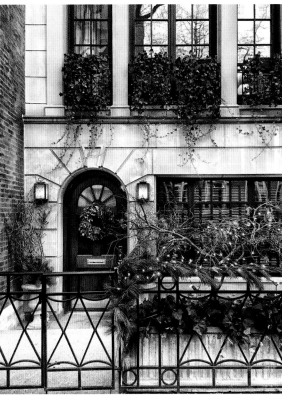
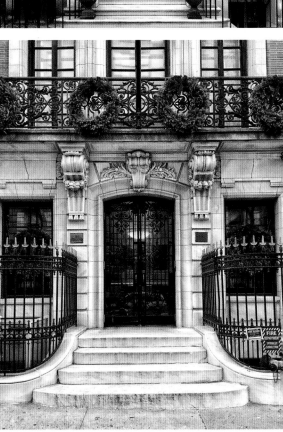

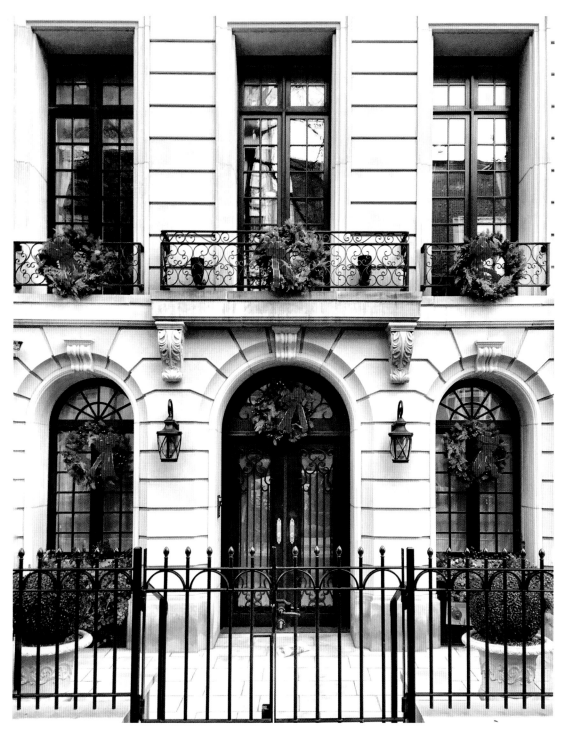

OPPOSITE: A collection of festively decorated facades throughout the neighborhood: boxwood-lined stoop, East 71st Street; classic columned entryway, East 73rd Street; ornate wrought-iron door, East 82nd Street; sparkly garlands, East 81st Street **ABOVE:** A classic limestone mansion decked out in holiday wreaths on East 81st Street between Park and Lexington Avenues

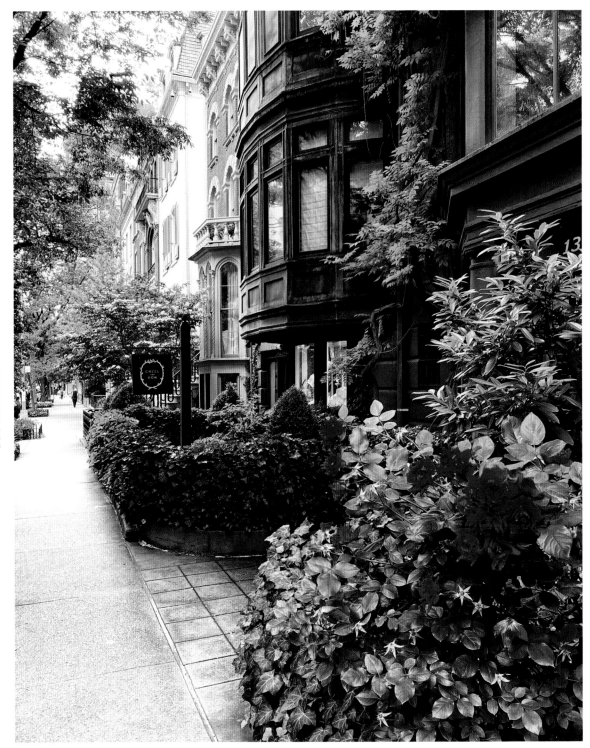

ABOVE: A beautiful bay window and lush landscaping on picturesque East 70th Street between Park and Lexington Avenues

My Favorite Streets

UPPER EAST SIDE

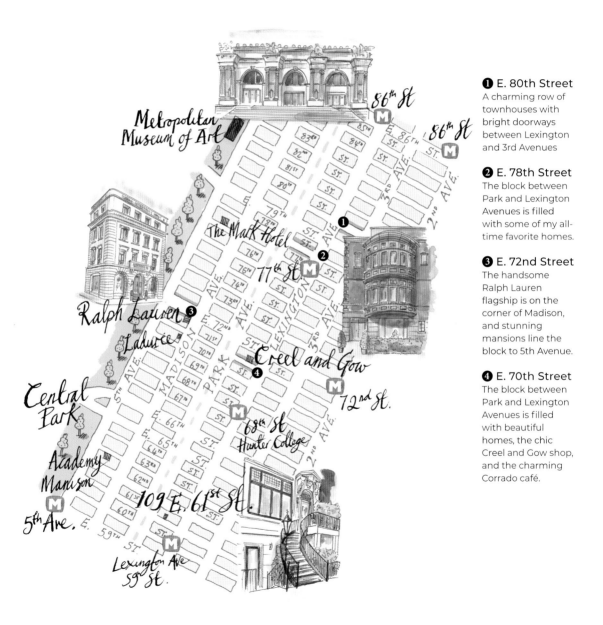

❶ E. 80th Street
A charming row of townhouses with bright doorways between Lexington and 3rd Avenues

❷ E. 78th Street
The block between Park and Lexington Avenues is filled with some of my all-time favorite homes.

❸ E. 72nd Street
The handsome Ralph Lauren flagship is on the corner of Madison, and stunning mansions line the block to 5th Avenue.

❹ E. 70th Street
The block between Park and Lexington Avenues is filled with beautiful homes, the chic Creel and Gow shop, and the charming Corrado café.

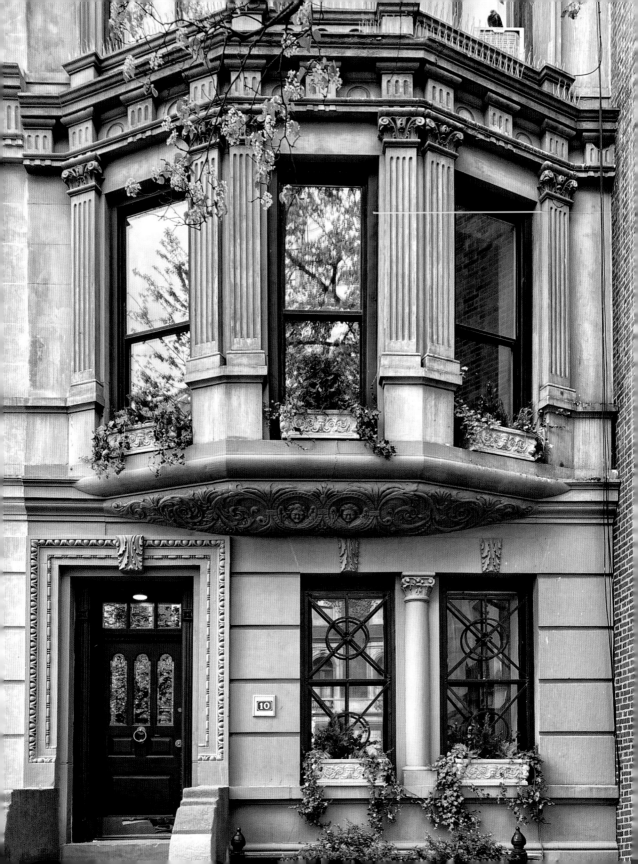

CARNEGIE HILL

Carnegie Hill, named for the industrialist and philanthropist Andrew Carnegie's 1902 mansion on 91st Street and 5th Avenue, is a quiet enclave within the upper confines of the Upper East Side. Stretching only from 86th to 96th Streets and from Central Park to 3rd Avenue, it's a small neighborhood, but it certainly packs a big punch! Home to New York City's Museum Mile, it includes the Cooper Hewitt, Smithsonian Design Museum (in Carnegie's former mansion); the Jewish Museum, housed in philanthropist Felix Warburg's French Gothic château–style home; and the Solomon R. Guggenheim Museum, famously designed by architect Frank Lloyd Wright.

My visits to these museums are what first introduced me to this neighborhood (otherwise I might never have ventured so far uptown). But when I took the time to actually explore the side streets beyond 5th Avenue and the museums, I became enamored with Carnegie Hill's quiet, old-world charm. I couldn't resist snapping photos of the beautiful ivy-covered facade on 93rd Street and Madison Avenue, across the street from the delightful Corner Bookstore. I was instantly charmed by two of the oldest wood frame houses in New York City on 92nd Street, the row of stunning brownstones with bay windows on 95th Street, and illustrator Abe Hirschfeld's eye-catching pink townhouse farther down the block. And I always look forward to checking out the lovely landscaping along the Park Avenue Mall, planted by the Carnegie Hill Neighbors Association—tulips and cherry blossoms in April and May, multicolored mums in the fall, and holiday trees in winter. And whatever time of year, it's hard to resist a walk through Central Park to enjoy the spring blooms or changing autumn leaves. Carnegie Hill has been called New York's "quintessential residential neighborhood," and I can see why.

An elegant gray neo-Renaissance townhouse apartment on East 95th Street between Madison and 5th Avenues

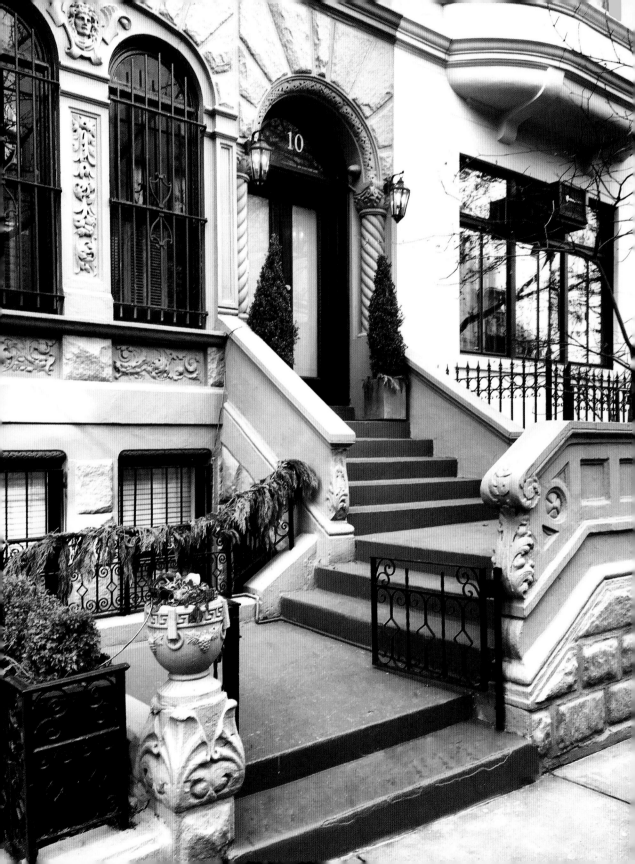

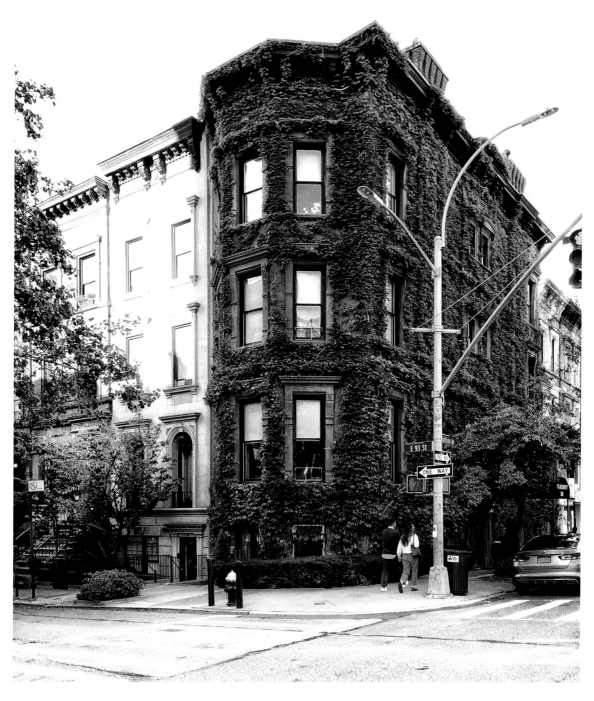

OPPOSITE: Holiday garlands adorn this handsome row house on East 92nd Street.
ABOVE: A charming ivy-covered building on the corner of Madison Avenue and East 93rd Street

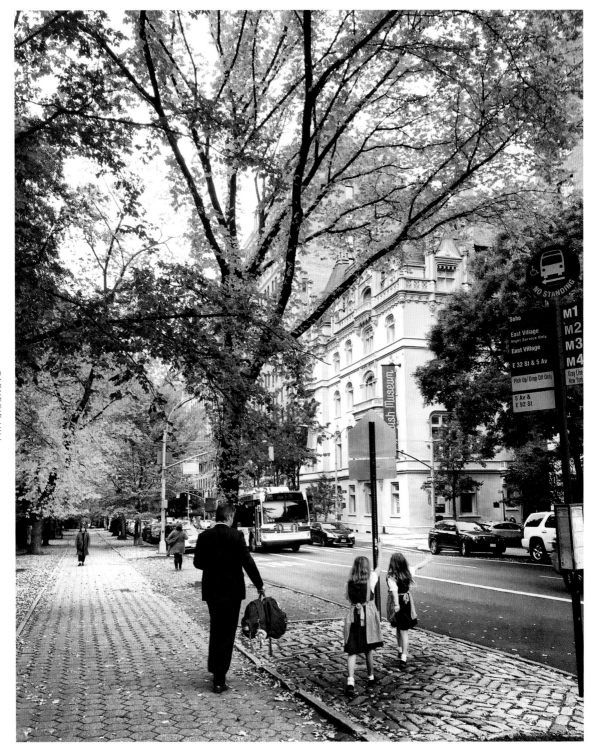

ABOVE: Schoolgirls in sweet pinafores hail a city bus on 5th Avenue and East 92nd Street.
OPPOSITE: Brilliant fall foliage in Central Park

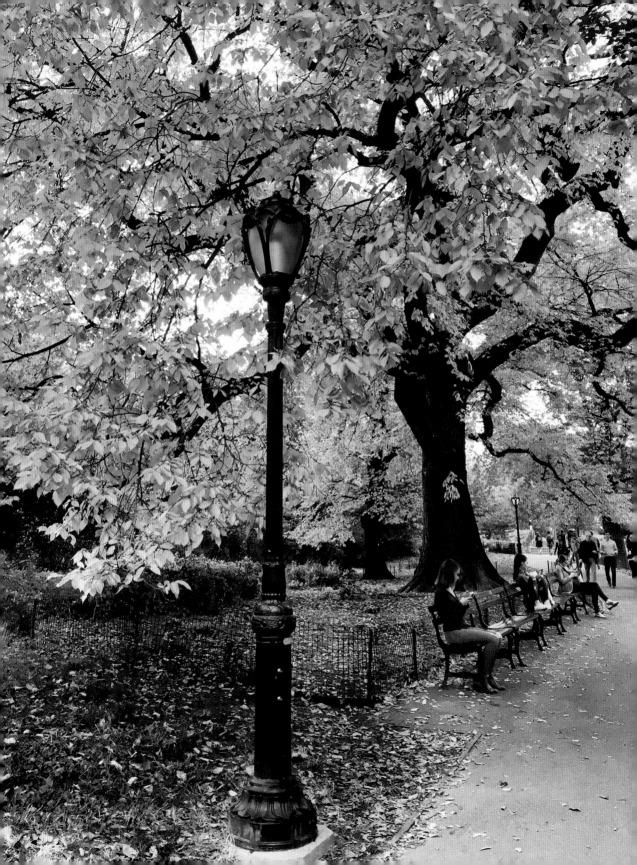

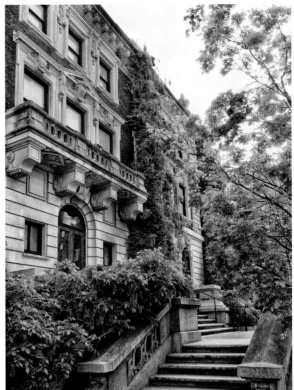
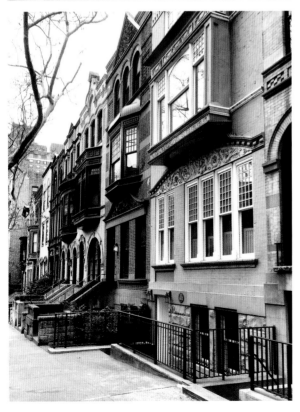
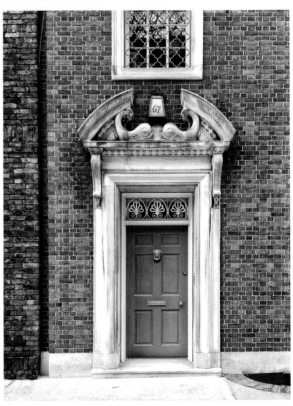

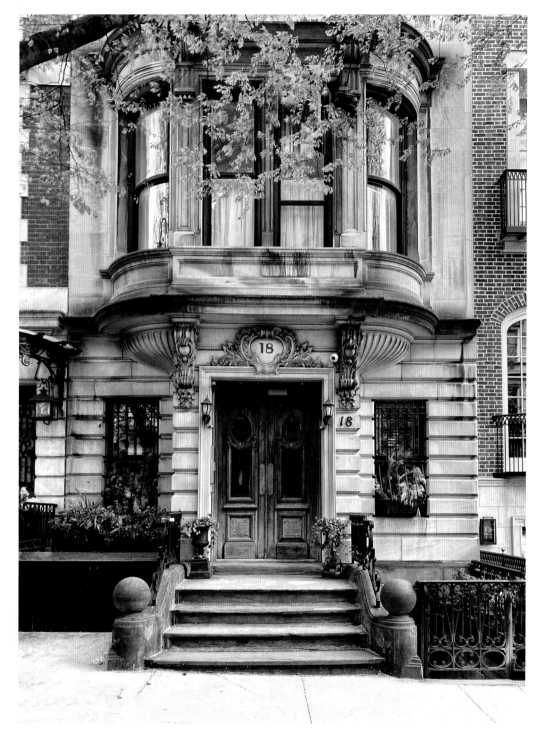

OPPOSITE, CLOCKWISE FROM TOP LEFT: A turquoise door and topiary on East 94th Street; the Cooper Hewitt, Smithsonian Design Museum; eye-catching door details on East 93rd Street; a pink townhouse on East 95th Street **ABOVE:** Embellished wood doors and a classic bay window on East 94th Street

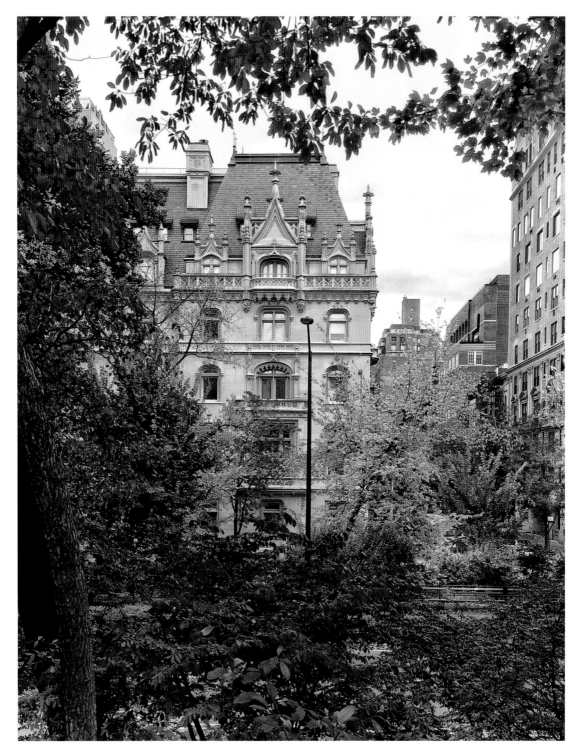

ABOVE: The Jewish Museum's ornate Gothic spires peeking through the richly colored fall foliage in Central Park **OPPOSITE:** A festive pumpkin-lined stoop on East 93rd Street between Madison and 5th Avenues

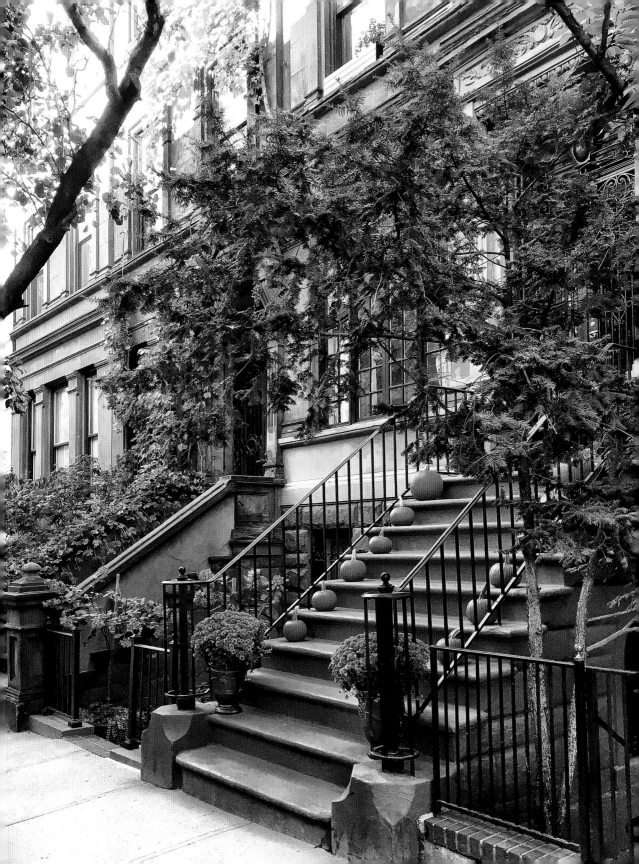

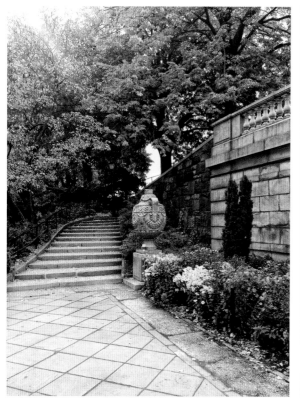
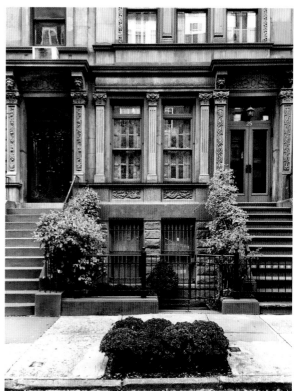
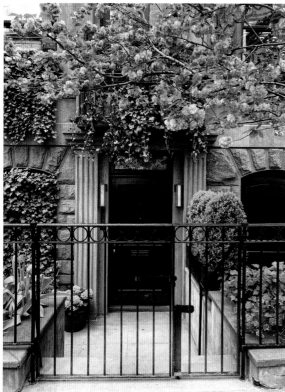
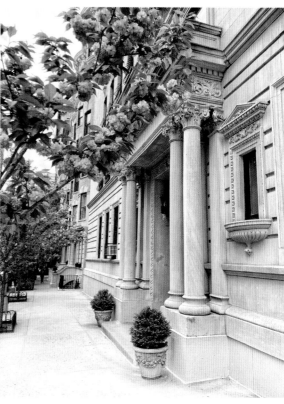

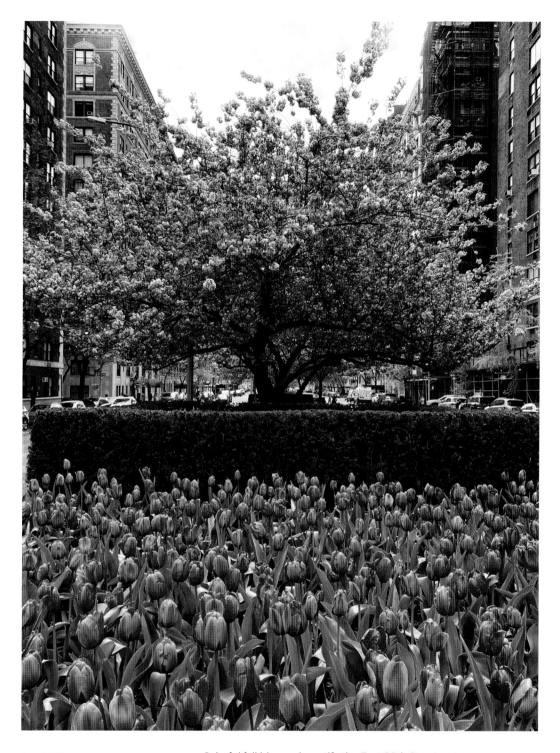

OPPOSITE, CLOCKWISE FROM TOP LEFT: Colorful fall blooms beautify the East 90th Street entrance to Central Park; magenta mums and a rust facade make a statement on East 92nd Street; Corinthian columns and pink cherry blossoms on East 93rd Street; a lovely mix of greens and pinks on East 91st Street **ABOVE:** Park Avenue Mall's stunning red tulips and pretty pink cherry blossoms

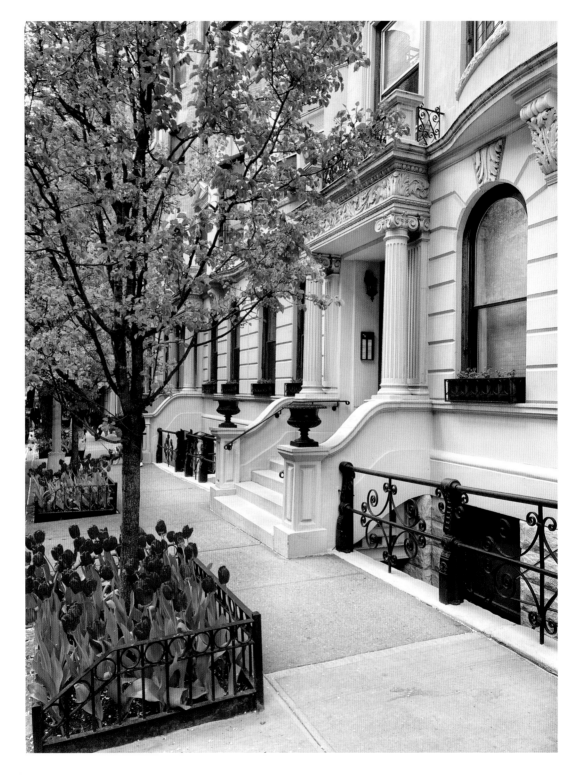

ABOVE: Planters filled with bright-red tulips add color along the sidewalk on East 95th Street, an elegant block between Madison and 5th Avenues.

My Favorite Streets

CARNEGIE HILL

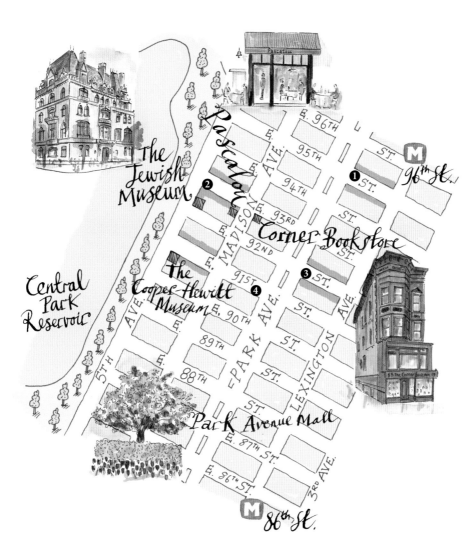

❶ E. 95th Street
Between Park and Lexington, you'll discover a gorgeous row of townhouses with striking bay windows.

❷ E. 93rd Street
A stunning block of ivy-covered brownstones between Madison and 5th Avenues

❸ E. 92nd Street
Worth a walk between Park and Lexington Avenues for two historic clapboard houses on the south side of the street

❹ E. 91st Street
A beautiful block of homes with many architectural details. It's particularly pretty in the springtime.

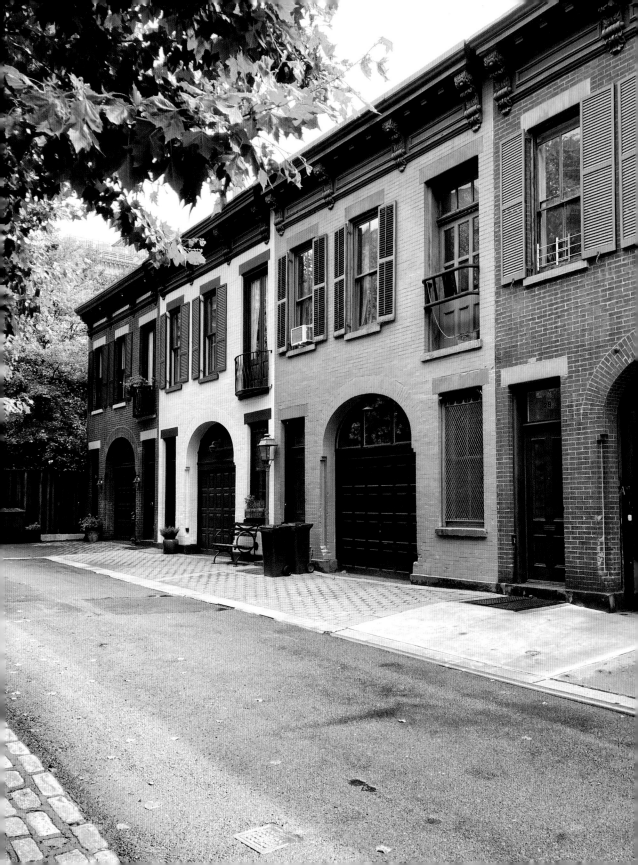

BROOKLYN HEIGHTS

Brooklyn Heights, dubbed New York's first "commuter suburb," was first advertised as a country retreat from Manhattan back in 1823. But until the Brooklyn Bridge was completed in 1883, the only way to actually commute to Brooklyn Heights was by ferry. Now, of course, you can hop on a subway, or, better yet, you can take a picturesque walk across the bridge to find yourself in the most beautifully preserved neighborhood in Brooklyn. With more than six hundred pre–Civil War era homes, it was also the first NYC neighborhood to be designated a historic district by the passage of the 1965 Landmarks Preservation Law. And for sheer variety of architectural styles—Greek Revival, Federal, and Italianate, to name a few—and an impressive literary history—Truman Capote, Walt Whitman, W. E. B. Du Bois, Arthur Miller, and Carson McCullers all lived and wrote here—it can't be beat!

I can't believe how long it took me to actually make that walk across the bridge (only four years ago!). But as they say, better late than never. Once I discovered the neighborhood's charming mews filled with beautifully restored carriage houses, cobblestoned streets, stunning mansions and brownstones, early-nineteenth-century clapboard houses, the "fruit streets," and the best view of Manhattan, from the Promenade, I was hooked. (And it's all within a very walkable fifteen-block by fifteen-block radius.) Since that first jaunt, I've returned many times (mostly by subway) to walk its streets, and each time I do, I feel like I've taken a mini vacation to a quaint but elegant little village—physically so close to Manhattan, but a world away in spirit.

A delightful row of painted brick carriage houses on College Place, a secluded little cul-de-sac

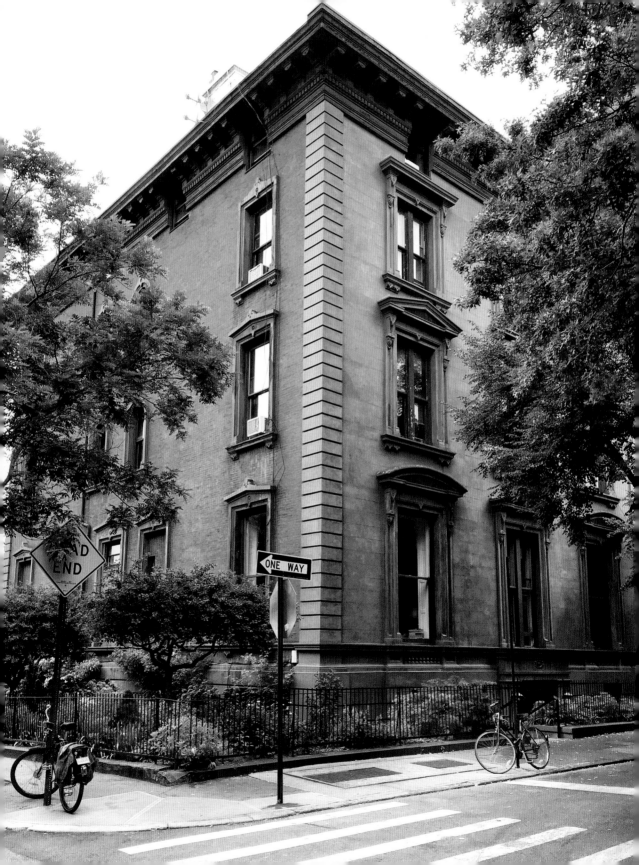

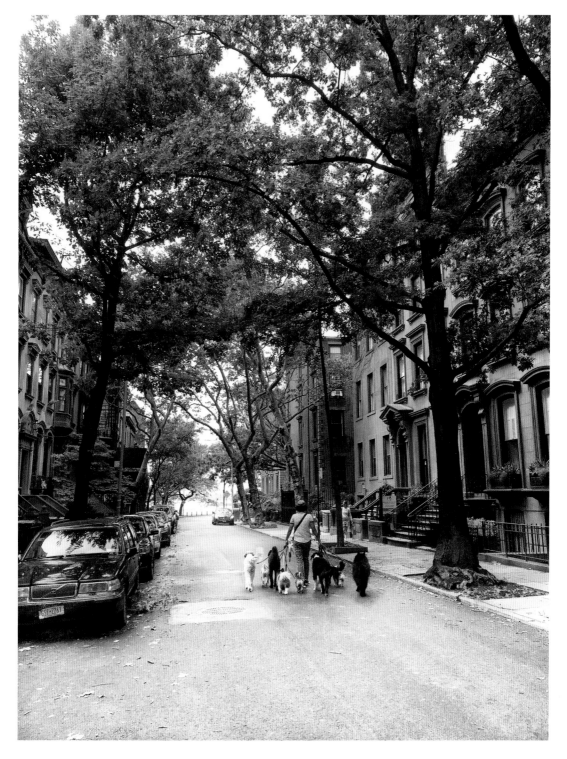

OPPOSITE: A stunning private mansion on Montague Terrace enjoys its own flower-filled summer garden and views of the East River. **ABOVE:** A dog walker on tree-lined Remsen Street leads the pack toward the Promenade.

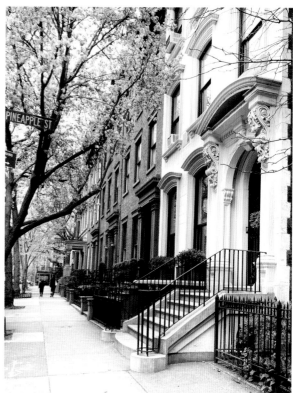
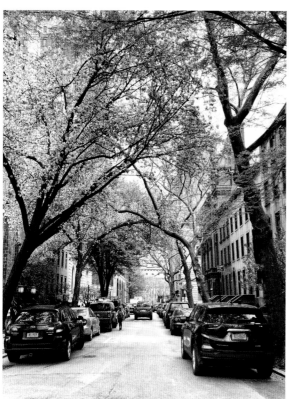
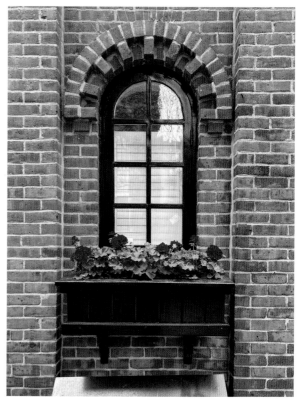

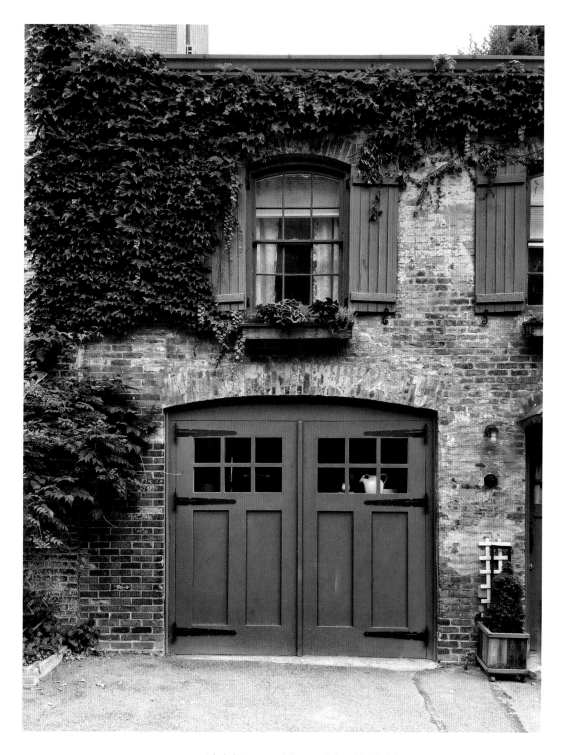

OPPOSITE, CLOCKWISE FROM TOP LEFT: A bright orange bike on Columbia Heights; a row of elegant townhouses on Columbia Heights; a window box filled with red geraniums on Pineapple Street; a lovely natural canopy on Pierrepont Street **ABOVE:** A charming ivy and trumpet vine–covered carriage house on Hunts Lane

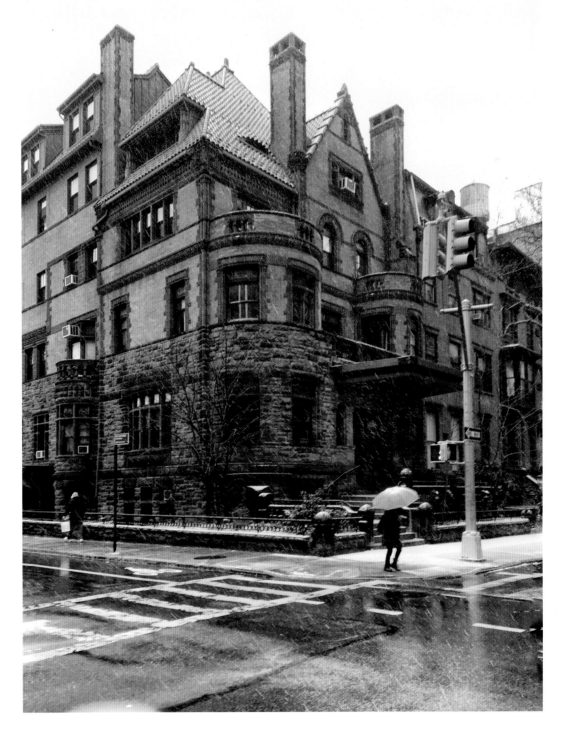

ABOVE: A pink umbrella pops against the exquisite Herman Behr Mansion on the corner of Pierrepont and Henry Streets. **OPPOSITE:** A rustic wood door and sweet flowerpots grace a Columbia Heights brownstone.

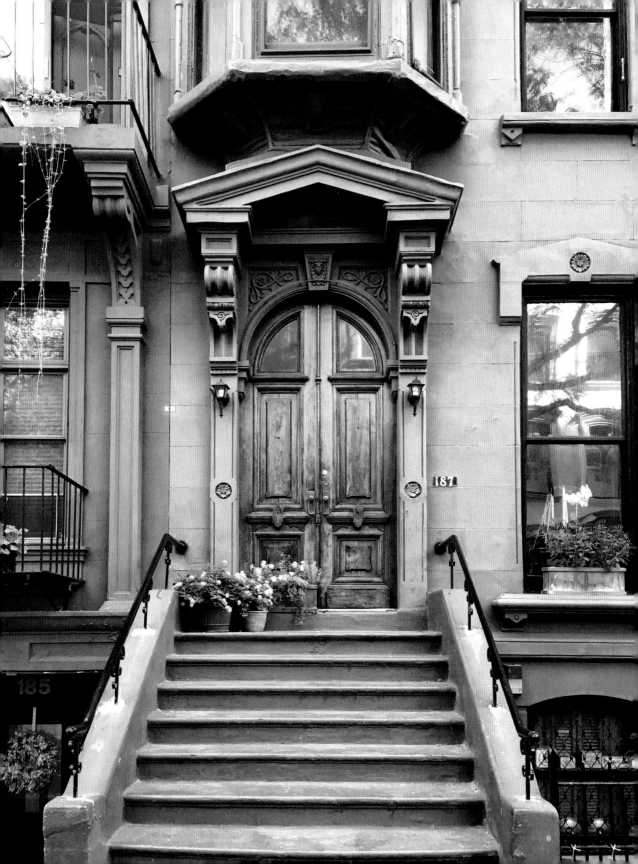

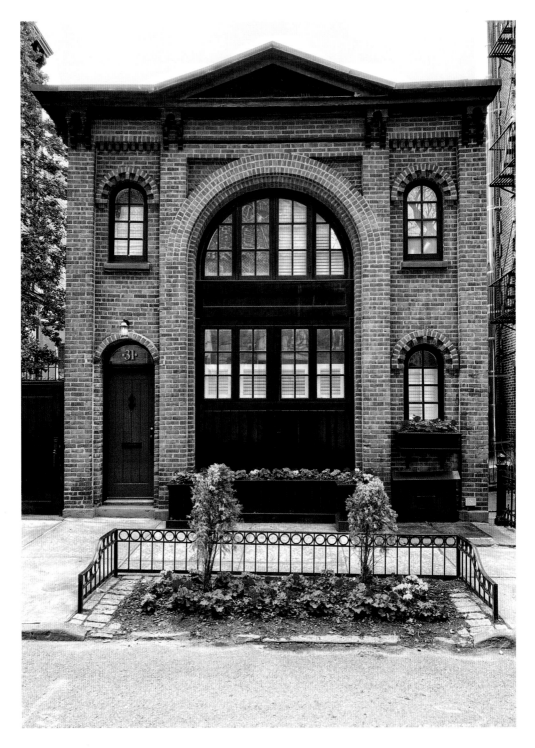

ABOVE: A charming private home on Pineapple Street was once a fire stable, built in 1880.
OPPOSITE, CLOCKWISE FROM TOP LEFT: Grace Court Alley's beautiful brick carriage houses; a dramatic arched window in Grace Court; a yellow brick carriage house on Sidney Place; a classic carriage house on Willow Street

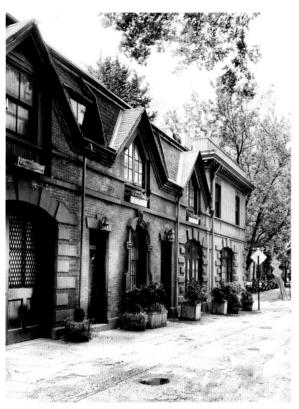
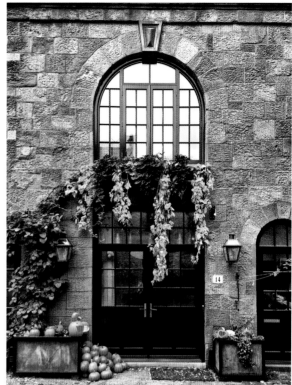
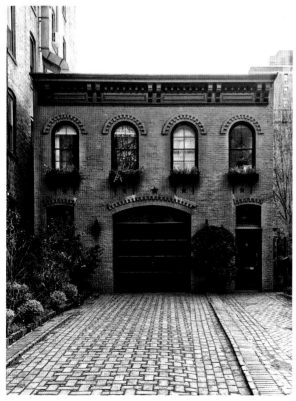
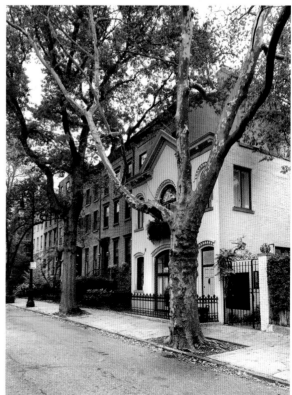

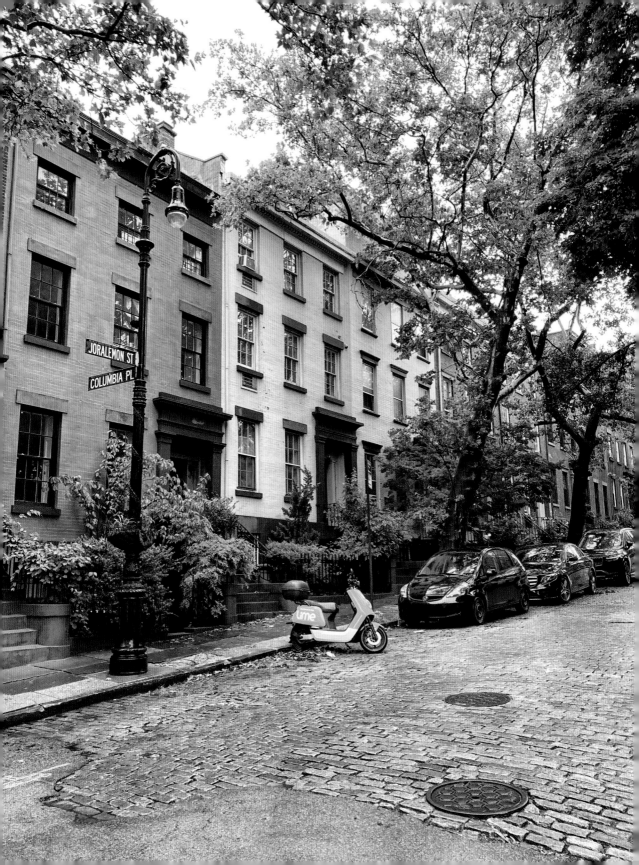

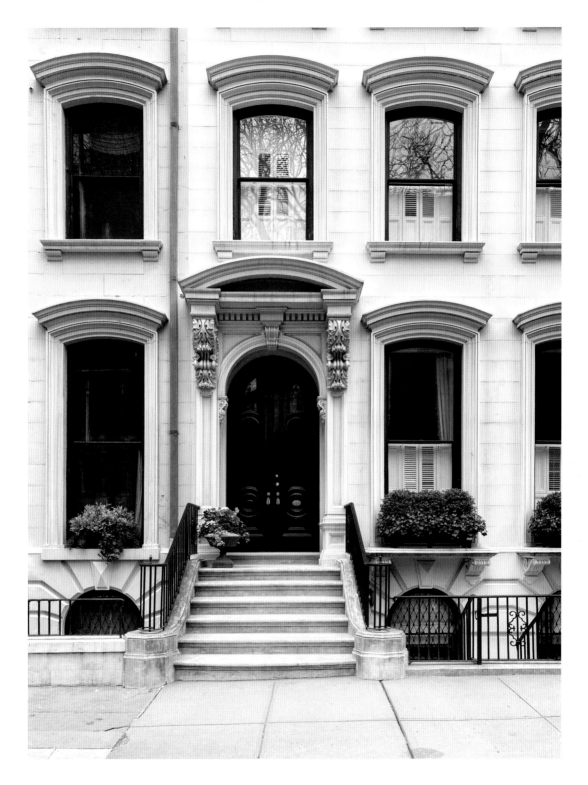

OPPOSITE: Colorful row houses on quaint cobblestoned Joralemon Street
ABOVE: An elegant Italianate townhouse on Columbia Heights

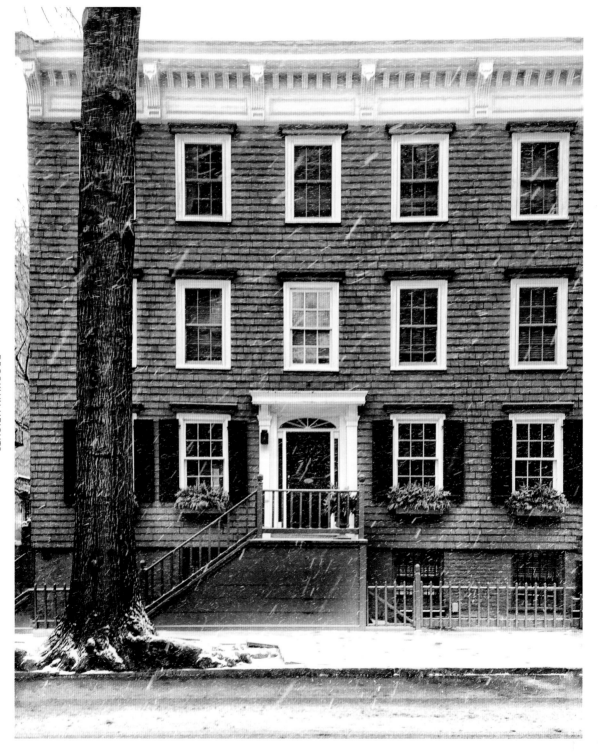

ABOVE: A historic 1830s Federal-style wood frame house on Pineapple Street
OPPOSITE: Columbia Heights townhouses on a snowy February day

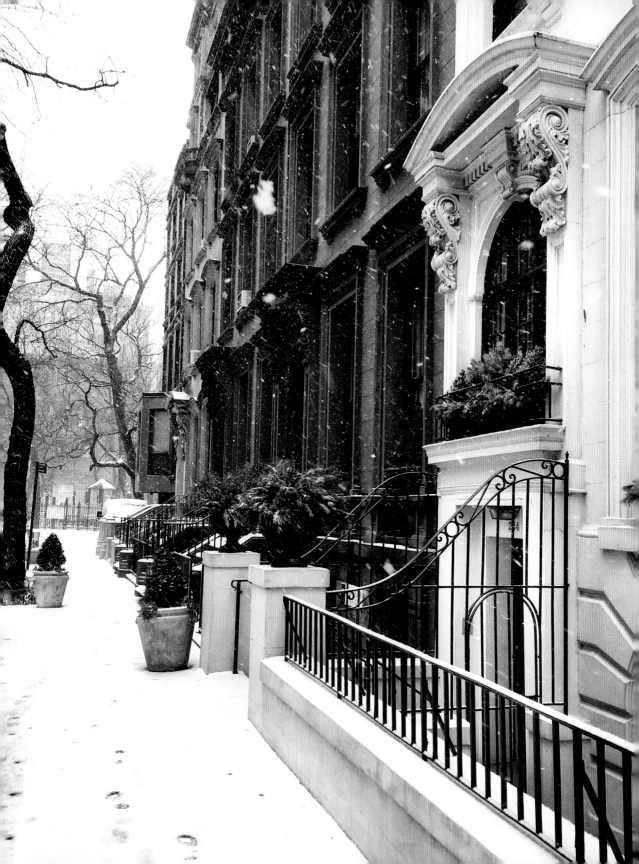

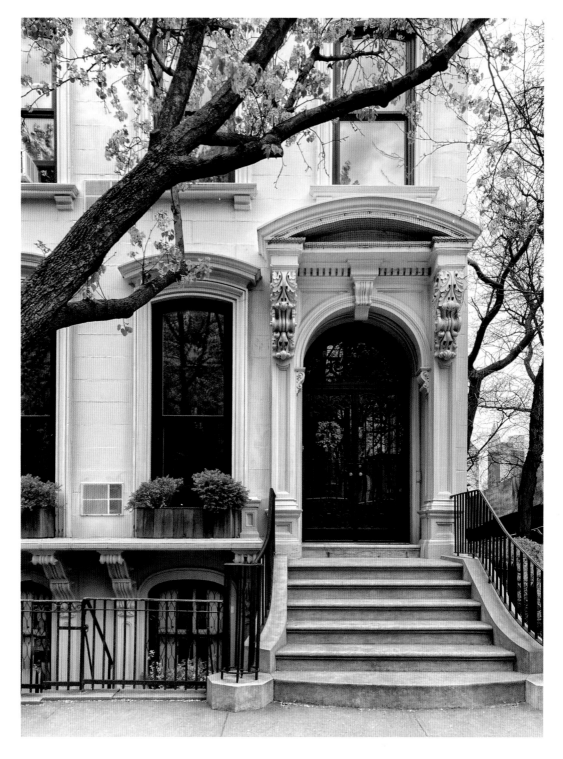

ABOVE: An ornate wrought-iron door on Columbia Heights **OPPOSITE, CLOCKWISE FROM TOP LEFT:** A blue door on Willow Street; a bold red door on College Place; a red door and pink bike on Willow Street; a historic clapboard house (ca. 1822) with red shutters on Middagh Street

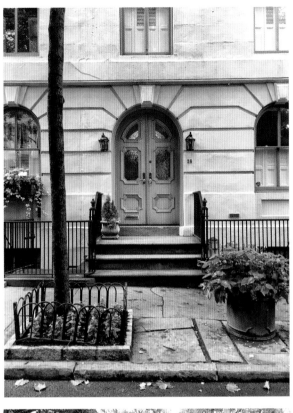
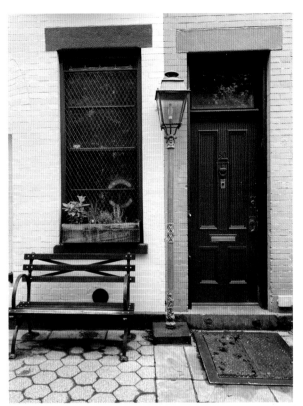
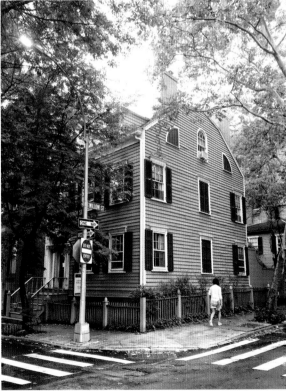
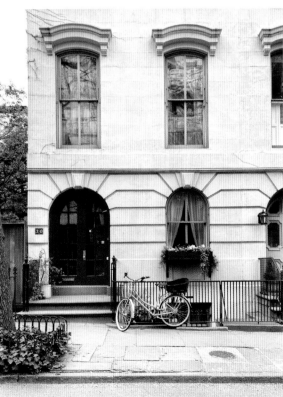

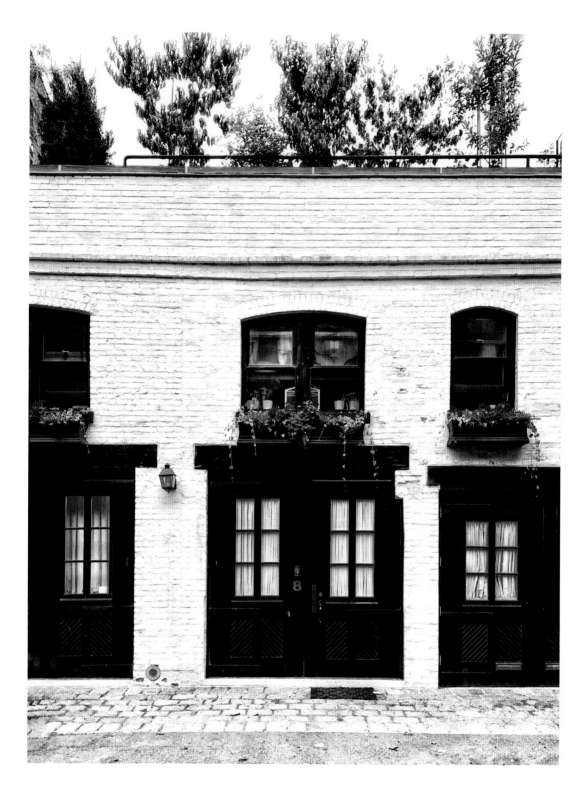

ABOVE: A graphic black-and-white carriage house on Hunts Lane

My Favorite Streets

BROOKLYN HEIGHTS

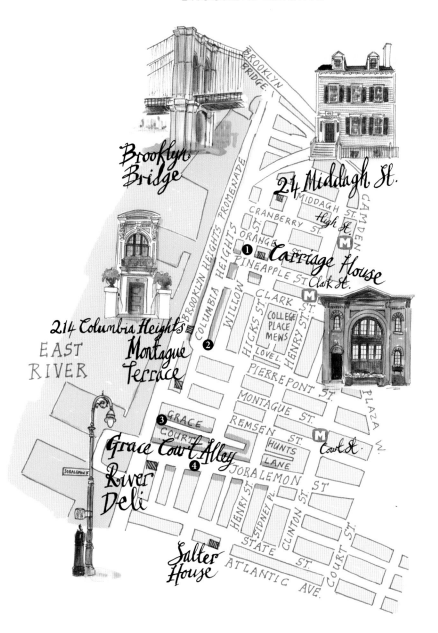

❶ Pineapple Street
Some of my favorite houses, a historic Federal-style home and a converted fire stable, can be found between Columbia Heights and Hicks Street.

❷ Columbia Heights
The most outstanding variety of elegant townhouses, between Pierrepont and Pineapple Streets

❸ Grace Court Alley
The most charming lane, with converted mid-nineteenth-century carriage houses

❹ Joralemon Street
A quaint three-block stretch of colorful brick and clapboard houses between Columbia Place and Sidney Place

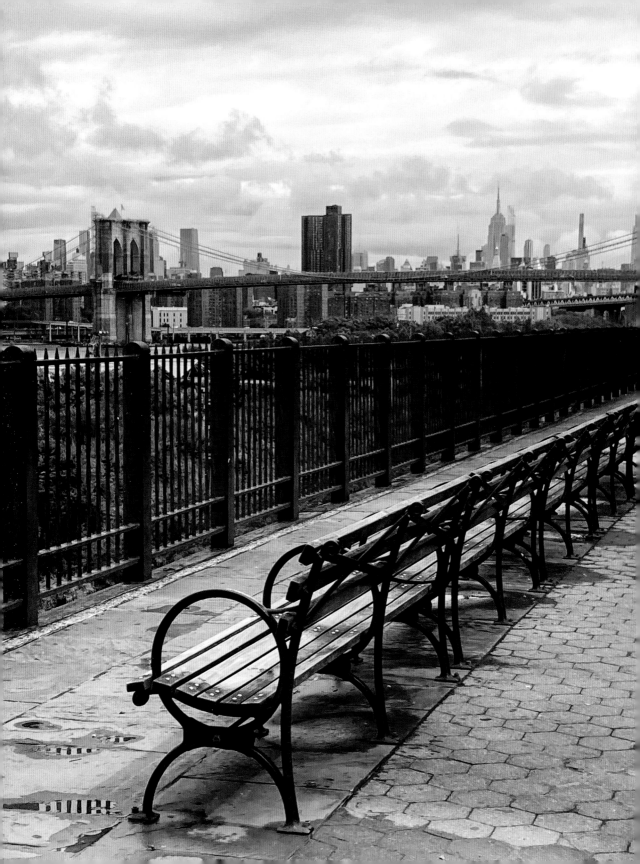

Dedicated to my father, who loved photographing architecture and flowers, and would have gotten such a kick out of this book

Acknowledgments

My most heartfelt thanks to my wonderful Instagram family for following along. Without you this book would not have been possible. And to my fellow NYC Instagrammers, thank you for your beautiful and inspiring daily posts.

Thank you to all the New York City preservation organizations and preservation advocates past and present for protecting the architecturally, historically, and culturally significant buildings in our city. Without their efforts so much of what you see in this book wouldn't exist today.

Creating *Walk With Me: New York* was not a solo endeavor. I am so lucky to have had these supportive and talented people in my corner. My deepest thanks go to:

My husband, Shawn Young, who has been by my side cheering me on every step of the way. Without his expertise and unwavering support, this book wouldn't be what it is.

Rina Stone, for her early collaboration on this project. Her beautiful proposal design helped get this book off the ground.

My agent, Kristin van Ogtrop, who turned this idea into a reality and patiently guided me through the process.

My editor, Rebecca Kaplan, for her belief in this book, and for graciously allowing me so much creative freedom; designer Darilyn Carnes, for her beautiful and classic book design; and the entire fantastic Abrams team.

Michael A. Hill, for his incredibly charming and beautifully rendered map illustrations.

Jenny Comita, who finessed my words; Sara Luckey who generously shared her photo imaging skills; and Cynthia Conigliaro, Christine Ganeaux, Andrea Linett, and Jeannie Park for their support and advice along the way.

My mother, who was the calm and steady voice I needed to keep me on track throughout the making of this book.

My family and friends, for their excitement and enthusiasm—you know who you are!

About the Author

SUSAN KAUFMAN (@skaufman4050) is a photographer, a former fashion director at Condé Nast Publications, and the founding editor in chief of Time Inc.'s *People StyleWatch* magazine. Her photographs have appeared in numerous publications, including *Glamour*, *Hamptons* magazine, and *Vogue Australia*. She splits her time between her Greenwich Village apartment and her home in Amagansett, which she shares with her husband and her black Labrador, Lucky.

Editor: Rebecca Kaplan
Designer: Darilyn Lowe Carnes
Managing Editor: Lisa Silverman
Production Manager: Rachael Marks

Library of Congress Control Number: 2021946834

ISBN: 978-1-4197-5937-6
eISBN: 978-1-64700-749-2

Printed and bound in China
10 9 8 7 6 5 4 3 2 1

Abrams Image books are available at special discounts when purchased in quantity for premiums and promotions as well as fundraising or educational use. Special editions can also be created to specification. For details, contact specialsales@abramsbooks.com or the address below.

Abrams Image® is a registered trademark of Harry N. Abrams, Inc.

 ABRAMS The Art of Books
195 Broadway, New York, NY 10007
abramsbooks.com

PAGE 1: West 10th Street between 5th and 6th Avenues **PAGE 2:** Detail of magnolia blossoms on East 16th Street **PAGE 3:** Richly detailed entrance on East 71st Street between Madison and 5th Avenues **PAGE 4:** Grove Street between Hudson and Bedford Streets **PAGE 6:** Window box detail on Waverly Place between West 10th and Christopher Streets **PAGE 174:** A view of the Brooklyn Bridge and the Manhattan skyline from the Brooklyn Heights Promenade